W9-ANI-688

ND 813 .G7 G773 OVERSIZE

Goya, Francisco, 1746-1828.

Goya

ND 813 .G7 G773 OVERSIZE

Goya, Francisco, 1746-1828.

Goya

DATE DUE

APR

NOV

OCT

AP

DATE

APR 2 4 2006 ISSUED TO

FRANCISCO DE GOYA Y LUCIENTES

GOYA

TEXT BY

JOSÉ GUDIOL

Director, Instituto Amatller de Arte Hispánico, Barcelona

THE LIBRARY OF GREAT PAINTERS

HARRY N. ABRAMS, INC., *Publishers,* NEW YORK

Translated by Priscilla Muller

International Standard Book Number: 0-8109-0149-8
Library of Congress Catalog Card Number: 64-10760

CONTENTS

FRANCISCO DE GOYA Y LUCIENTES by José Gudiol

BIOGRAPHICAL OUTLINE

DRAWINGS AND PRINTS

COLORPLATES

Goya

FRANCISCO DE GOYA Y LUCIENTES was born to Gracia Lucientes on March 30, 1746, in a small house on a narrow and dusty street in Fuendetodos, Spain. The home in Fuendetodos, a poor agricultural village amid rocky hills in one of Aragon's most deserted and dry regions, was temporary, and the great painter's childhood years were passed in Saragossa. There his father, José Goya, had a modest gilder's shop and his grandfather had been a notary, though the origins of the family were Basque. In Saragossa, young Goya attended Father Joaquin's school, where he formed a close friendship with Martín Zapater. The copious correspondence between these two friends, though inadequately published, provides one of the basic sources for our present knowledge of Goya's personality.

Unfortunately, facts relating to the painter's earliest years are not very plentiful. They have been gathered from a spoken tradition, from writings dating shortly after his death, and from casual references in the Zapater correspondence. At thirteen or fourteen, Goya became an apprentice in the studio of José Luzán, a dexterous painter who regularly produced the large religious canvases that were part of ecclesiastical decoration during the final years of the Baroque.

Saragossa, seat of the Archbishopric, was always the artistic center of far-flung Aragon. From hundreds of small towns buyers came to Saragossa's art workshops—as they come even today—seeking sumptuous

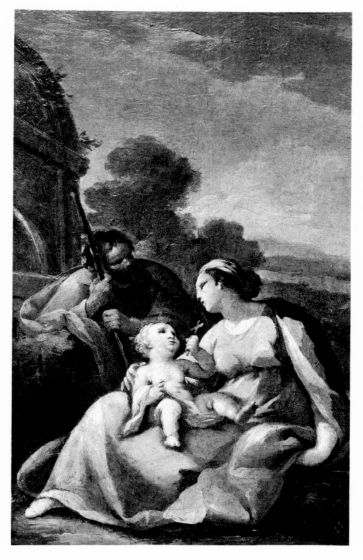

1. THE HOLY FAMILY. Before 1771.
Oil on canvas. *Collection Simonsen, Geneva*

9

2. THE VIRGIN APPEARING TO SAINT JAMES
(detail from Reliquary Cabinet Paintings). *c.* 1763.
Fuendetodos Parochial Church (destroyed in 1936)

decorations for innumerable village churches. The Aragon school of painting provides one of the most interesting and full chapters in the history of Spanish art. Its style is characterized by vigor and by decisiveness of color; the style establishes a somewhat crude, though aesthetically certain, rhythm of form and color which endows the image, and even simple decorative elements, with an inimitable stamp. Goya, who emerged precisely at a crucial moment in Aragonese art—when it had succumbed to the bland mode of provincialized rococo—is in fact universally recognized as the leading exponent of a great school maintained by artists and artisans throughout the centuries. With surprising harmony, the mysterious thread that winds through the distinct art of each locale unites all that Goya produced in his paintings, drawings, and etchings with the severe style of Aragon's medieval masters. It is in a like manner that Picasso represents, in essence, the universal extension of this rough yet sensitive complex which is called Spanish art.

In four years of daily work at Luzán's studio, Goya learned to prepare canvases and colors; he saw how a theme might be developed by combining compositions and figures copied from prints with rough sketches from nature. The endless flow of engravings arriving in large numbers from France, Italy, and Flanders was the effective means by which the representative arts were internationalized; they started an upheaval that finally destroyed the individuality of the minor schools. Hard and monotonous studio work demanding, above all else, rapid production and mastery of the elements of the painter's trade contributed considerably to the development of Goya's superior natural gifts by furnishing him with the basic knowledge necessary to begin as a painter. Very probably the only paintings known to be of this apprenticeship period were those on the wooden doors of a reliquary cabinet in the parochial church of Fuendetodos, destroyed in 1936 (figure 2). Below some hangings supported by angels, these earliest paintings depicted *The Virgin of the Carmen, San Francisco de Paula,* and *The Appearance of the Virgen del Pilar* ("Virgin of the Column"), a pre-eminent Aragonese theme. Goya's iconographically traditional figures reflect Luzán's pictorial formulas in the modeling of light and shade. Even through the distortions (more apparent than real) of the poor photographs available, a notable analytical endeavor is visible. The traditional dating of these paintings in the years preceding Goya's apprenticeship is not acceptable. Sufficient skill required for this work is compatible only with the period of Goya's work in Luzán's studio; thus, the year 1763 is more reasonable as their approximate date.

On December 4, 1763, Goya was in Madrid, participating unsuccessfully in a scholarship competition held by the Royal Academy of Fine Arts of San Fernando. For several years thereafter, no specific references exist concerning the artist's life and work. In July, 1766, young Goya, then twenty, again failed before the Madrid Academy. He did not attain a single favorable vote, despite the presence on the tribunal of Francisco Bayeu, an Aragonese painter established at Madrid. Bayeu, the foremost of three brothers who were painters, was a principal exponent of the aesthetic academicism introduced into Spain by

Anton Raphael Mengs. It seems certain that the first stage of Goya's artistic development took place in Madrid during a period of work with Bayeu. In a letter written at Rome in 1771 concerning a competition at Parma, Goya declared himself Bayeu's pupil. This personal relationship explains Goya's acquaintance with Josefa Bayeu, to whom he was married in 1773, one year before his own establishment in Madrid; she was a sister of the three painters and had lived with them in Madrid.

Gossip and legend had described the youth of the Fuendetodos painter as one devoted to fights, knifings, and romantic incidents; such accounts were enthusiastically collected by Goya's earliest biographers. To moderate this poor reputation, Martín Zapater's nephew published some of Goya's letters to his uncle,

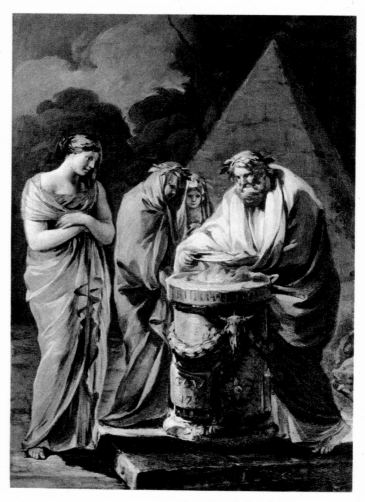

4. SACRIFICE TO VESTA. Signed and dated 1771. Oil on canvas, 13 × 9¹/₂″. *Private collection, Barcelona*

3. PORTRAIT OF MANUEL VARGAS MACHUCA (detail). Signed and dated 1771. Oil on canvas. *Collection Bardi, São Paulo, Brazil*

thereby revealing something of the painter's true nature. In point of fact, Goya had an unruly and quarrelsome disposition, a rudimentary education, and a forthright petulance. His youthful letters disclose his great frankness, as well as his affection for bullfights, hunting, and popular fiestas.

Various works have been proposed as indications of Goya's activity during the years between his first trip to Madrid and his stay in Italy; in most instances, these attributions lack stylistic foundation. It is true that the Fuendetodos reliquary cabinet was destroyed before having been adequately studied and photographed. Consequently, reconstruction of Goya's stylistic development prior to works signed and dated in 1771 is most uncertain. Nevertheless, three oil paintings on canvas may with absolute conviction be attributed to him: the small-sized *Holy Family*

5. CHOIR VAULTING DECORATIONS (portion). *c*. 1773.
Chapel of the Virgin, El Pilar Cathedral, Saragossa

nied the painting submitted by Goya to the Parma Academy—a lost work, praised by the Parma jury. Signed and dated 1771, the portrait, *Manuel Vargas Machuca* (figure 3), and a pair of small canvases representing scenes of sacrifice to Pan and Vesta (figure 4) were painted by Goya during his visit to Rome. By June, 1771, Goya had returned to Saragossa. In the portrait of 1771, the academic formula is balanced by a certain realistic aura achieved by the smile of the sitter; a skillful *sfumato* ("blending of light and shaded areas") dissolves the linearity, particularly in the face, thus showing that Goya had already initiated one of the pictorial principles that constitute his characteristic manner. The sacrificial scenes take place amid trees, low sunlight producing strong reflections and very fine shadows; the execution is as free and impassioned as that of the later Goya

6. A FATHER OF THE CHURCH (portion).
c. 1773. Wall painting in oil. *Sanctuary of the Virgin of the Fountain, Muel (Saragossa)*

(figure 1) and *Lamentation Over the Dead Christ* (Collection Simonsen, Geneva) and *The Appearance of the Virgen del Pilar* (Collection Quinto, Saragossa). The stylistic relationships of these paintings to those of Francisco Bayeu are obvious, but Goya's demonstrate a keener technique, a superior analytical power, and a richness of color that corresponds perfectly with signed works to be discussed presently. Each figure has an independent nature, as happens in primitive painting, but their sum total is harmonious. The impasto is thick, and the brush strokes render a typically Goyesque liveliness that results from a combination of both vigorous and most subtle touches.

Writing in 1779, Goya declared that while he had been in Rome (in 1771), he had "carried on and lived at his own expense." However, documentary evidences concerning this trip to Italy are few. There is the letter dated at Rome in April, 1771, which accompa-

7. WALL PAINTING (portion). 1774. Oil on canvas. *Church of the Carthusian Monastery of Aula Dei, Saragossa*

paintings less imbued with Neoclassicism. Of excellent workmanship, the scenes employ colors anticipating the original manner which is typical of Goya's mature works.

That Goya was established as an independent painter in Saragossa by 1771 is corroborated by his tax declarations. It seems probable that the wall paintings in oil for the chapel of the Sobradiel Palace, owned by the Counts of Gabarda, were among his first works in that city. The compositions were most probably dictated, since the *Visitation, Dream of Saint Joseph,* and *Burial of the Saint* were almost wholly copied from engravings by Vouet and Maratta. The small *Saint Anne, Saint Vincent Ferrer, Saint Cayetano,* and *Saint Joachim,* which complete the series, seem to

be original. The tactile quality of a certain flame-like form, notable in the folds of the fabrics, somewhat detracts from the dramatic effect. In technique, a joy in the pictorial material and in workmanship itself are already indicated. In the separate images a taste for the emotional appears with great intensity.

These paintings, and other works now lost, occupied Goya's initial months at Saragossa. However, it was not long before he obtained an important commission, the decoration of the choir vaults of the stately chapel of the Virgin, designed by Ventura Rodríguez for the great basilica of the Virgen del Pilar. This project offered Goya an opportunity to prove his knowledge of the fresco technique. By January, 1772, a large sketch, *The Adoration of the Name of God by the Angels,*

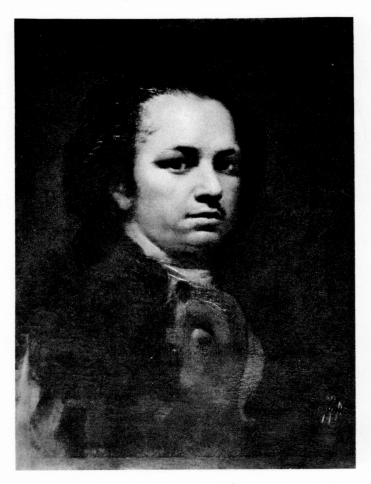

8. SELF-PORTRAIT. *c.* 1774. Oil on canvas.
Collection Marquis of Zurgena, Madrid

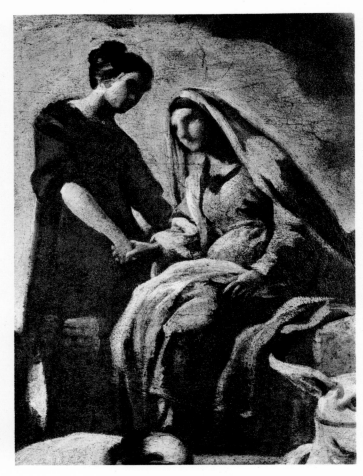

9. THE VISITATION (detail). 1777. Oil sketch
on paper, $26^3/_8 \times 18^1/_2''$. *Collection G. Ricart, Barcelona*

was completed. The fresco, which follows the sketch exactly, was finished in June of the same year (figure 5). Here may be seen the first culmination of Goya's art, achieved by means of skillful effects of light and a boldness of technique. Far from simply following methods learned at Madrid, Goya improvised new solutions to suggest form, movement, and space, in a manner probably derived from his Italian experience.

Study of the sketch on which Goya worked for two months is instructive for an understanding of his stylistic development. Overpaintings and revisions reveal the great analytical power developed by Goya, surpassing the stereotyped formulas of Baroque decoration. Extremely complex planning of opposing lights, and the violent impact of direct lights and bold reflections, disclose his desperate seeking for the elements necessary to materialization of the idea. Goya balanced the light in his painting to suggest the

contrast between the illumination of his subject and the rays of daylight which streamed into the choir through the large windows.

In proportion to Goya's enormous capacity for work and the untiring productive rhythm sustained throughout his life, only very few works are identifiably of this period. Unprejudiced analysis of paintings attributed to Goya and his contemporaries in Saragossa would be useful and perhaps surprising in its results. It is difficult, for example, to accept the almost complete loss of lesser works that Goya could have executed during his youth. Several paintings which are undoubtedly related are: two small sketches at the Saragossa Museum; a portrait, *Man with Hat;* also at the Saragossa Museum; and two series of *Fathers of the Church* painted for churches at Muel (figure 6) and Remolinos. These series were based on a single set of sketches, though in each instance Goya introduced

14

modifications for their adaptation to the structure of each building. At Remolinos, the paintings are in oil on canvas. Those of Muel were executed in oil, but on the walls. The technique is based on a superimposing of simple values, permitting rapid modeling of forms and chiaroscuro (light and shade). Initially, these compositions were set forth in very fluid earth colors and dark tones. Final modeling and finishing touches—in ochers, whites, vermilions, blues, and blacks—were savagely applied in strokes of exaggerated impasto. The procedure Goya employed paralleled that of the preparatory sketches then so useful to Spanish painters, drawn in black-and-white on dark paper. We observe that Goya from the beginning employed a technique of synthesis which in other artists constitutes a sign of maturity. For this reason, there is basically little difference between the stirring Remolinos paintings executed before the age of twenty-eight and those of the Quinta del Sordo (House of the Deaf Man), which Goya painted in his seventies. The

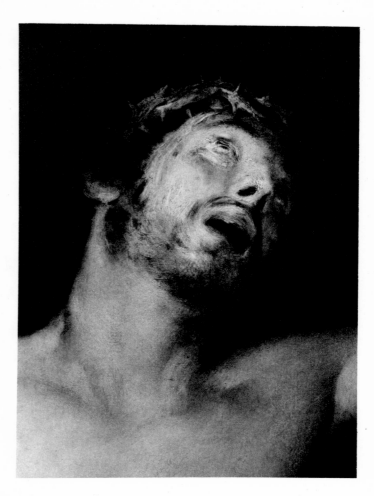

11. HEAD OF CHRIST (detail from the CRUCIFIXION). Presented by Goya to the Academy of San Fernando in 1780. Oil on canvas, 100 × 60¹/₄″. *The Prado Museum, Madrid*

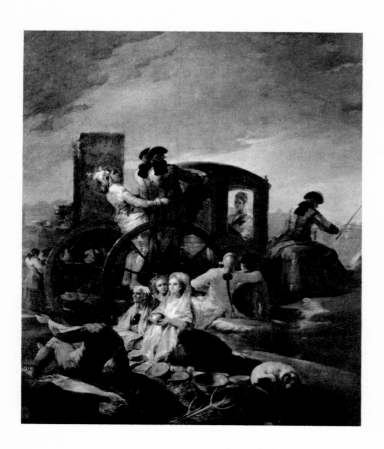

10. THE CROCKERY SELLER. Delivered in 1779. Tapestry cartoon, oil on canvas, 102 × 86⁵/₈″. *The Prado Museum, Madrid*

differences are not fundamental, but are the evidence of life's hard lessons, of literary influences, and of experience acquired in an exalted labor.

On July 25, 1773, Goya and Josefa Bayeu were married in Madrid. However, Goya could not have been absent from Saragossa for any length of time, since his name appears without interruption in the city register of artisans' contributions. It was precisely after his marriage that Goya completed the extraordinary wall paintings of the Carthusian monastery of Aula Dei (page 75 und figure 7). From data gathered by Fray Isidoro Maria Estudillo, it is now known that the paintings were executed between April and November of 1774. One is astonished, even considering Goya's talents as a creator, that in only seven months he could have completed eleven compositions, each of which averages about 250

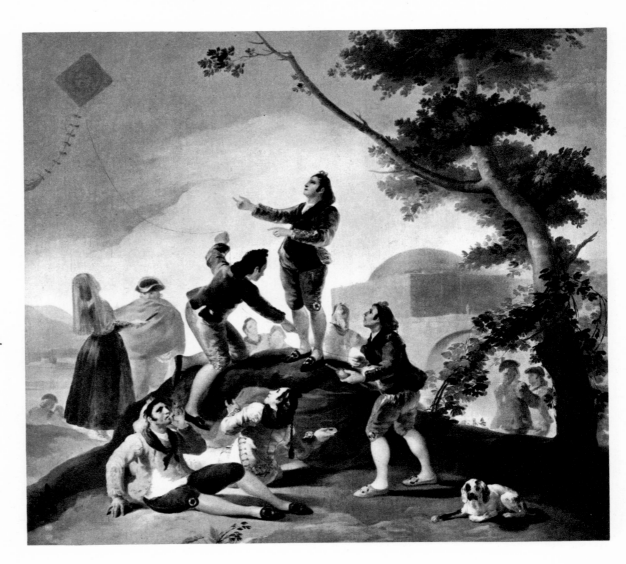

12. THE KITE. Delivered in 1779.
Tapestry cartoon,
oil on canvas, 106 × 113".
The Prado Museum, Madrid

square feet. A particularly rapid technique was used, modeling with light strokes on a dark ground, suggesting effects with the fewest possible elements, and absolutely dispensing with any insistence on labored brush strokes. The first period of Goya's art culminates in these paintings.

1775–92

Goya states in one of his writings that he was called to Madrid at the close of 1774 by Anton Raphael Mengs, who wished him to paint cartoons for the Royal Manufactory of Tapestries. It was most probably Francisco Bayeu who agreed, at the urging of his sister Josefa, Goya's wife, to employ the painter in the execution of work at the Royal Manufactory. Actually, the twenty-eight-year-old Goya had already achieved artistic success before he left Saragossa. As

fiscal records of that city prove, Goya had attained in three years of work the highest level among taxpaying painters, surpassing in income even his own master, Luzán, and the old Mercklein, Francisco Bayeu's father-in-law. A self-portrait of this period— the earliest known—shows us Goya's optimistic appearance, and reflects health and prosperity (figure 8). It is painted with simplicity and candor, as if to suggest the maturing of his faculties and the inner satisfaction derived from his great work for the Aula Dei monastery. In Madrid, the young husband lodged in Bayeu's house, and there his first son, baptized on December 15, 1775, was born.

In an admirable book, Valentin de Sambricio has published a critical and documented study of Goya's participation in the works of the noted Royal Manufactory of St. Barbara. It was this establishment which

provided the innumerable tapestries decorating the royal palaces and residences. Almost all of the cartoons executed there are preserved—the majority in the Prado Museum at Madrid—as are also the complete documentary references concerning each painter's contribution to this work. The Royal Manufactory of Tapestries, together with other manufactories similarly established, was the most important bequest of the Bourbon rulers to the development of Spanish art. Goya's first undertaking, in May, 1775, consisted of five cartoons. They demonstrate so submissive and mediocre a style that, prior to Sambricio's investigations, none was attributed to the Fuendetodos master. A rapid recuperation of Goya's own personality is manifested in four canvases painted during the second half of the year. Yet they, and others, remain considerably distant from the Aula Dei paintings, and even from the small religious scenes of 1771 mentioned earlier. The change from the freedom that Goya had enjoyed in Aragon to the rigid discipline of work under Bayeu clearly created a feeling of inferiority from which Goya did not fully recover until the relationship was violently broken six years later.

It may be suspected that Goya really was always weak—firm in his art, but insecure in his relationships with the outer world. Despite his achievements, there may be continuously glimpsed the reactions, of a timid man, governed by emotion and somewhat lacking in self-confidence. From the misery surrounding his childhood, he always retained a chronic fear of poverty. Thus, he was constantly more preoccupied with small professional rivalries and economic problems than with the conception of a work of art. However, his art was effortlessly produced, he brought to the creative process simply his instinct and the nimble hand that painted with miraculous synchroni-

13. REGINA MARTYRUM (portion). 1780–81. Cupola fresco. *El Pilar Cathedral, Saragossa*

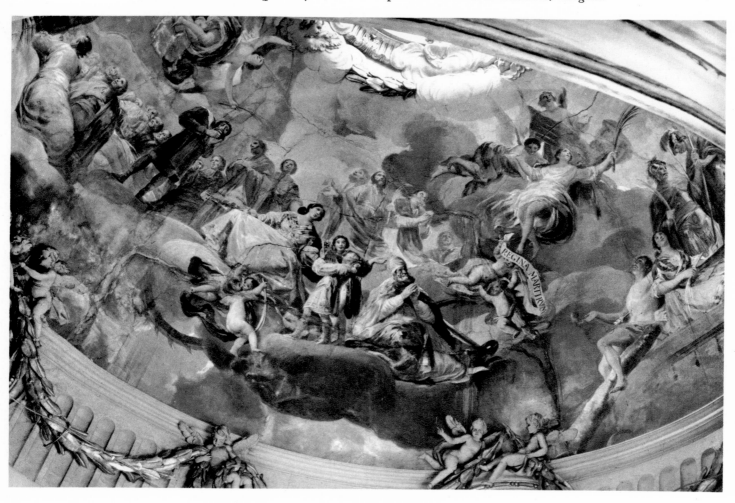

zation the products of his imagination and his aesthetic purpose. With little experience and counsel, he was able to paint the 900 square feet of the Pilar fresco in four months—and in slightly more time, the enormous Aula Dei compositions. In both works, improvisations, discoveries, and rewards came to him, in contrast to the earliest cartoons, plagued with the hesitations of an apprentice. The gap in quality between Goya's Aragonese paintings and the insufficiencies of his early Madrid works fully justifies the lack of interest of historians in whatever he accomplished before putting his brushes to the service of the Crown.

A single cartoon of 1776, *The Picnic*, leads one to expect that Goya would begin working in accordance with his capability. One of his earliest Madrid works, the *Portrait of the Count of Miranda* (Lázaro Museum,

14. PORTRAIT OF CANON PIGNATELLI (detail of study). 1780–81.
Oil on canvas, $31^1/_2 \times 24^3/_8''$.
Collection Duke of Villahermosa, Madrid

Madrid), was painted in 1774; in it is exhibited the porcelain-like finish that had been imposed on court circles by Mengs. The live flame of Goya's creativity, almost freed of the yoke imposed by the cartoons, may be seen in a small group of paintings produced in 1777. These include an additional version of the scene representing Aragon's patron, the *Virgen del Pilar* (Collection Muñoz, Barcelona), a very beautiful study of *The Visitation* replete with nostalgic reminiscences of the Aula Dei paintings (figure 9), a *Saint Peter* (Collection Marquis of Casa Torres, Madrid), a pair of small religious pictures at Valencia's Cathedral, and a *Saint Barbara* (Collection Torelló, Barcelona). All of these paintings were for clients of modest means or for friends from Aragon living at the Madrid court.

Goya's self-confidence is seen reborn in five cartoons commissioned in 1777. Notable accents were attained in *The Maja and the Cloaked Men*, and particularly in *The Parasol* (page 77), one of the most popular of Spanish paintings. During the following year, Goya continued producing cartoons, earning for five commissioned between January and April a sum equivalent to his income of the entire preceding year. After an interruption due to illness—known through the letters to Zapater—Goya resumed work for the Royal Tapestry Manufactory, delivering several compositions at the beginning of January, 1779. Among these was *The Crockery Seller* (figure 10), which, together with *The Kite* (figure 12) and *The Blind Guitarist*, is with reason numbered amongst the best of Goya's cartoons. The painter continued to devote his efforts completely to the cartoons. Late in January, 1780, Goya was able to deliver eleven cartoons; outstanding among these were such interesting works as *The Washerwomen* (page 79), *The Bullfight*, and *The Doctor*. With this group, the first cycle of Goya's collaboration with the royal factory came to an end, the Crown necessarily discontinuing its extravagances in order to support the war against England. In compensation for his work, Goya was elected a member of the Royal Academy of Fine Arts of San Fernando. In accordance with its rules, he presented to the Academy the painting *Crucifixion*, a work that unjustly earned abundant adverse criticism (detail, figure 11). Actually, Goya had intended to create a

work strictly within academic canons, and had made use of an example by Bayeu, itself a servile transcription of a Mengs *Crucifixion*. However, even in this effort Goya not only surpassed those who were, academically speaking, his acknowledged masters, but he successfully added an original expressiveness to the head of Christ, in perfect accord with the best of his own style. A replica of this *Crucifixion* by Goya's own hand is in the Toledo Museum.

Collaboration in Crown undertakings offered Goya an opportunity to study the superb royal collections; thus he came to know the art of Velázquez. In 1778, Goya sent a series of etchings reproducing paintings by the great seventeenth-century artist to his friend Martín Zapater. Arbitrary interpretations and abundant, evidently involuntary transformations of facial features produce an aspect of fantasy, anticipating works of Goya's old age. These modifications must also have been the cause of the economic failure which Goya encountered with this series, the first he intended for publication. These unfortunate plates reveal—as do the earliest tapestry cartoons and the Sobradiel Palace paintings at Saragossa—Goya's inevitable failure when obliged to copy in a servile manner the work of others.

The impact of Velázquez's pictorial conception is, however, immediately reflected in Goya's tapestry cartoons. In those of small format, particularly in the series dedicated to children's games, he used lengthened brush strokes and a color density appropriate to the form. In large compositions he acquired a permanent mastery of atmospheric effects and discovered the pictorial value of reflected light. He was able to adapt, as had no other painter, the discoveries of the great seventeenth-century master. In a later period, Goya would succeed similarly in enriching his technique by adapting certain of Murillo's misty vibrations.

Goya again lived in Saragossa between October, 1780, and June, 1781. The Council of Works of El Pilar Cathedral had recalled him from Madrid to participate in their program of decoration. Oil sketches and the final cupola fresco dedicated to the *Regina Martyrum* (figure 13) were painted by Goya, as were four allegorical figures of the *Virtues*, placed in the triangular spaces formed by the arches. The latent

15. SCENE WITH VARIOUS FIGURES. 1780–81. Oil on canvas. *Aragonese Society of Friends of the Country, Saragossa*

argument between Goya and his brother-in-law, Francisco Bayeu, broke out with violence during execution of these works. Bayeu had been assigned the painting of the other cupola, and was officially regarded as director of the entire decorative scheme. The sad result of their conflict was that Goya lost the commission; he was obliged to humiliate himself, to present new sketches for the triangular units, and,

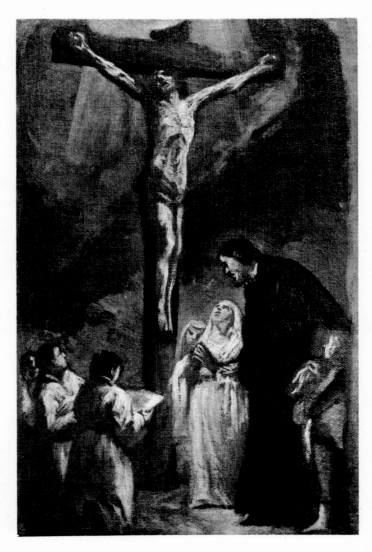

16. SAN JOSÉ DE CALASANZ BEFORE THE CRUCIFIXION. 1780–81.
Oil on canvas. *Collection Berriz, Saragossa*

realism of the sketches. The figures maintain the heroic canon that Goya preferred. However, in the synthesis of the Baroque and ideal Neoclassicism, an almost caricature-like aspect is occasionally intermingled. This occurs in the exaggeration of details and in the tragic quality of some heads and faces whose irregular outlines are one of the frequent traits of Goya's expressionism. Improvisation and an interest in brush stroke, traces of line, and pictorial material are continuously noticeable. The intensity of these characteristics is such that the protests of Bayeu and Goya's more academically minded contemporaries are understandable. Realizing the uncertain nature of his work at Madrid, Goya probably used his stay at Saragossa to resume contacts. Thus, as evidences of this period, the following works may be proposed: a study for the lost *Portrait of Canon Pignatelli* (figure 14), an enigmatic sketch of figures at the Aragonese Society of Friends of the Country (figure 15), and an impressive sketch, *San José de Calasanz Before the Crucifixion* (figure 16), which justifies Goya's famous declaration acknowledging Rembrandt, Velázquez, and Nature as his masters.

Early in July, 1781, Goya was again in Madrid, though without definite work at the Royal Tapestry Manufactory and without other known commissions. To the hardships of his struggle for existence were added the painful memories of Saragossa and the intrigues of colleagues envious of his rising prestige. Goya's frequent letters to Zapater offer a very valuable reflection of this crucial period. Soon, however, it was succeeded by one devoted to the painting of religious themes and portraits. On July 25, Goya wrote his faithful friend about a large painting commissioned for the church of San Francisco el Grande in Madrid. This commission was also, however, simultaneously assigned to several rival colleagues. Thus his victory in the resultant competition, publicly judged in October of 1784, was considered by Goya as his first success at the Madrid court.

Three preparatory sketches show the evolution of the work that depicted *The Sermon of Saint Bernard of Siena Before the King of Aragon, Alfonso V* (figure 17). The final canvas conforms somewhat to academic tastes. Goya took cognizance of his recent failure at

finally, to renounce his collaboration in what might have been the most important artistic undertaking of his native region.

In spite of the frequent restraints imposed by his troublesome brother-in-law, Goya kept in mind the deformations to be produced by distance, simplifying his forms and accentuating the dominant features. Nevertheless, this was probably less intended to ease the spectator's task than to gratify Goya's own passion for bold technique, as he experimented with daubs of color, rough sketchings, mere traces of line, almost dissolved forms, and modified proportions. And despite this technique—rich in expressive meaning, irregular, and most personal—the general appearance suggests idealizing, on comparison with the sharp

Saragossa, and here fails to demonstrate the qualities attained in the works of the Pilar and the Aula Dei. Goya himself is included in the audience of saintly figures; as a preparatory study, he painted the impressive self-portrait now at the Agen Municipal Museum.

During this most vacillating period of his career, Goya alternated the execution of this laboriously elaborated official work with various other paintings. The latter remain unidentified, since the number of recognized works of this period are insufficient to represent adequately the production of an artist of Goya's capacity. A portrait of the director of the tapestry manufactory, *Cornelius van der Goten*, was painted in 1781. The very much disdained Goya painting, *The Holy Family* (Prado Museum), disclosing the influence of Mengs, might, on the basis of its style,

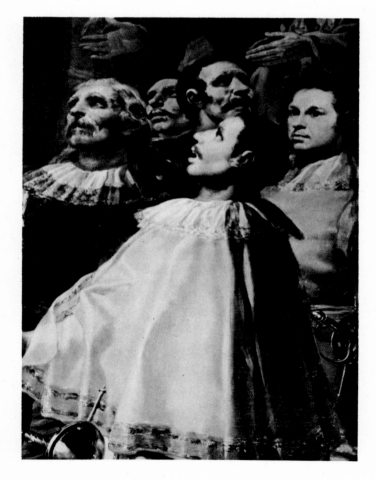

17. THE SERMON OF SAINT BERNARD OF SIENA
BEFORE THE KING OF ARAGON, ALFONSO V (detail).
1783-84. Oil on canvas, 169 × 118".
Church of San Francisco el Grande, Madrid

be assigned to this period. The large *Portrait of the Count of Floridablanca* was painted by Goya in 1783 (page 81). The figure, seen full length in a rococo setting, is accompanied by his secretary and by the painter himself, who offers a small canvas to the Count. The work is ambitious and has excellent passages. It is not without fault, but the preoccupation for accommodating the taste of others, noted in the painting then being completed for San Francisco el Grande, begins to give way. It might therefore be inferred that the portrait was not to the liking of the powerful minister, who paid Goya with unfulfilled promises.

In this same year, Goya enjoyed some weeks of happiness at Arenas de San Pedro, Avila, having been invited there by the Infante Don Luis. This unfortunate brother of King Charles III, who had renounced both the cardinal's biretta and the bishop's miter at Toledo, lived in Arenas de San Pedro apart from the court, following his marriage to Doña Maria Teresa Vallabriga, an Aragonese lady. Goya's letters of this time to Zapater reflect the bucolic setting. However, it is certain that he worked steadily, painting at least six portraits and an additional large composition of the Infante's family. In this family portrait, the wife of the Infante is seen attended by her hairdresser and is surrounded by her husband and children, the majordomo, and other servants. In the foreground, Goya portrayed himself in the act of painting. This very interesting work (Collection Ruspoli, Florence) is not generally accessible but is known from a smaller copy. However, three of the portraits executed in Arenas de San Pedro are available. In the portrait of the Infante, Goya drew nearer than ever to Mengs's pictorial conception, though he clearly surpassed Mengs in psychological insight and in technique, successfully giving preference to visual, rather than tactile, realism.

Even more interesting is the portrait of the Infante's wife (figure 18), executed with complete freedom, since Goya had had to paint it in very few sessions. In this portrait, Goya found his own direction. However, if considered as the starting point of a gallery of superb, pure Goya portraits, that of the Infante's wife does not appear exaggeratedly free. It possesses qualities identical to those seen in the por-

trait of the two-year-old future Countess of Chinchón and wife of Godoy, shown in an early portrait before a landscape background which apparently was taken from one of Goya's tapestry cartoons (figure 19). The remaining portraits Goya painted during this short summer period are not known to us, though they included a profile-bust portrait of Don Luis on the reverse of which Goya wrote "painted . . . from nine to twelve on the morning of September 11."

Goya was back in Madrid by September 20, before public presentation of the painting for San Francisco el Grande, noted earlier. No documentation concerning other works Goya painted at this time is known.

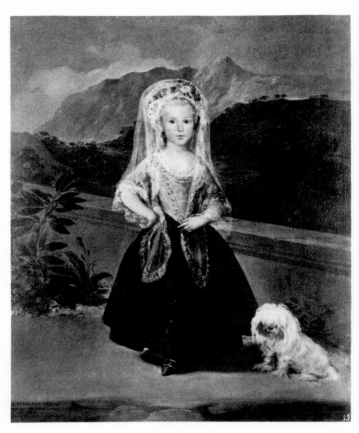

19. PORTRAIT OF MARÍA TERESA DE BORBÓN Y VALLABRIGA, COUNTESS OF CHINCHÓN. 1783. Oil on canvas, $52^7/_8 \times 46''$. *National Gallery of Art, Washington, D.C.*

18. PORTRAIT OF MARÍA TERESA VALLABRIGA. 1783. Oil on canvas. $76^3/_4 \times 51^1/_8''$. *Collection Ruspoli, Florence*

However, these might have included the exceptional full-length self-portrait in which Goya's hatted figure is vigorously silhouetted against the light (figure 20). Goya's son, in later describing this painting, included a special discourse on the painter's use of controlled candlelight, which enabled him to paint at night. In 1784, with the aid of Jovellanos, Goya received a commission for four canvases—now lost—for the Colegio de Calatrava at Salamanca. Also dated 1784 are an ironic representation of *Hercules and Omphale* (Collection Duke of San Pedro de Galatino, Madrid), a portrait of the boy *Vicente Osorio* (Collection Payson, New York), and that of *Ventura Rodríquez* (National Museum, Stockholm). It was during this same year that Javier Goya was born, the son who would carry on the name of the great painter.

In 1785, Goya obtained the modest position of Deputy Director of Painting at the Academy of San Fernando. Little by little, he penetrated into the wide

world of Madrid. Ceán Bermúdez provided him with a commission to portray *Don José de Toro y Zambrano* for the Bank of San Carlos; other portraits soon followed (Bank of Spain, Madrid). For the ducal house of the Medinaceli he painted a large *Annunciation*, the sketch for which (Collection Wildenstein, London) is a milestone in indicating a movement toward simplification of structure and color within Goya's rapid career. In works of this optimistic period, a slight change of palette is visible, and smooth, melting shades of color are sought. The outstanding *Portrait of the Duchess of Osuna* (Collection March, Palma de Mallorca) is a true masterpiece of Spanish portraiture, with which the portraits *Gasparini* and the *Count of Gausa* must be contemporary.

In 1786, Goya again undertook the execution of tapestry cartoons. In this new phase he worked with increased independence, giving greater importance to landscape, lighting, and surroundings, while sharpening feeling for the narrative and the real. However, he did not completely abandon conventional canons, deferring partly to the taste of those who commissioned the designs and partly to the limitations imposed by the rudimentary tapestry-weaving technique. Indeed, the weavers protested against complications caused by variations in tone and the excessive fluidity of manner in Goya's original compositions.

Resumption of work for the Royal Tapestry Manufactory earned for Goya the title of Painter to the King. Of the cartoons produced during this year, *The Flower Sellers*, *The Wounded Mason* (page 83), and particularly *The Snow* (figure 21) are outstanding for the realistic lighting of the surroundings Goya effected. Several portraits of 1786 are known, including *The Count of Altamira*, *The Marquis of Tolosa*, and *Charles III* (Bank of Spain, Madrid), as well as the *Mariano Ferrer* and *Francisco Bayeu* (Museum of Fine Arts, Valencia). In the Valencia portraits, somber hues presage the sobriety of Goya's later works.

During the year that followed, Goya delivered three paintings for the Church of Santa Ana in Valladolid. These pictures remain in the church, where they face three others of identical size by Francisco Bayeu. The aesthetic distance between the Goya and the Bayeu series is so great that, even without knowing the judg-

ments of the period, it may be supposed that the older, academic brother-in-law would have been considered the inferior artist in this second encounter between the two rivals. Before Bayeu's saccharine, affected images, Goya presented, in his *Saint Bernard Baptizing a Kneeling Man* (page 85), strongly interacting whites that approach in quality those by Zurbarán; in the sad *Death of Saint Joseph* scene, he attained passionate iridescences similar to those of Murillo. Indeed, all of this was certainly accomplished purely by instinct, for despite a renewed regard for Andalusian painting at the court—to which many examples were brought as a consequence of the personal preferences of Isabel Farnese, wife of Philip V—it is improbable that Goya had occasion to become acquainted with it. During

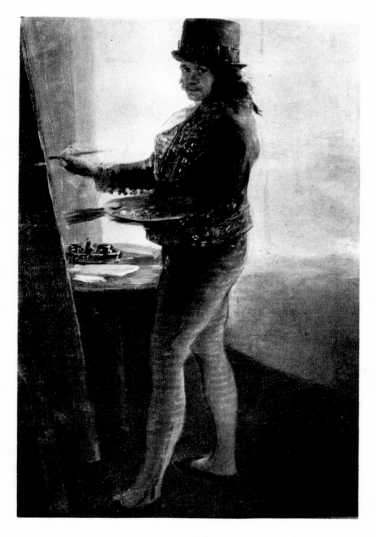

20. SELF-PORTRAIT. C. 1784. Oil on canvas, $16^1/_2 \times 11''$.
Collection Count of Villagonzalo, Madrid

1787, Goya also painted seven compositions for the Alameda, home of the Dukes of Osuna; genre scenes similar to those of the tapestry cartoons were represented. Freed of the limitations of the weaving technique, Goya's iridescent colors were enriched, and the entire decoration was executed with greater spontaneity. In these ornamentations in the French mode, the themes narrated take on a gay tint, like that of comedy scenes—even in the tragic *Assault on the Stagecoach*. The kaleidoscopic quality and the great sensitivity of these paintings is demonstrated in the beautiful *Portrait of the Marquesa de Pontejos*, justifiably often favorably com-

pared with the best of eighteenth-century English painting (page 87).

In June, 1788, Goya experienced a disheartening defeat at the Academy on not obtaining even one vote for the office of Director of the Division of Painting. As in the competition of 1766, another painter, Gregorio Ferro, of no significance in the history of Spanish painting, won over Goya. This result must not be considered as an unfavorable judgment of the accomplishments of Goya by his contemporaries but rather as an expression of resentment by the mediocre of the superior. Preparatory sketches for most of

21. THE SNOW. Delivered in 1786. Sketch for tapestry cartoon, oil on canvas, 12¹/₂ × 13″. *Collection Silbermann, New York*

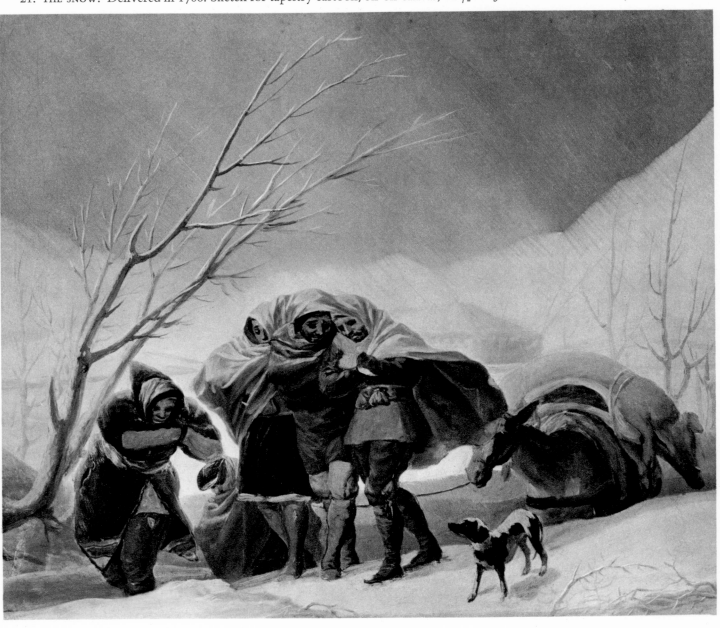

Goya's tapestry cartoons of 1788 remain; outstanding is the often-published *Meadows of San Isidro*, mentioned by Goya in his letters to Zapater as one of his major pictorial preoccupations. During the year, Goya also delivered the Valencia Cathedral's large canvases dedicated to exalt the veneration of St. Francis of Borgia. These theatrical compositions were painted more with determination than with enthusiasm. Nevertheless, passages of great quality were achieved, as in the familiar scene of the Saint's farewell. Shades of emotion and mystery are attained in the scene of a dying man surrounded by monsters and aided by the Saint, the first of Goya's hallucinatory series of paintings (page 89). During this period of intense activity, compositions and portraits alternated in Goya's œuvre. There filed past his palette *The Countess of Altamira with Her Daughter* (Collection Robert A. Lehman, New York), *The Count of Cabarrús* (Bank of Spain, Madrid), and the child, *Don Manuel Osorio de Zuñiga* (The Metropolitan Museum of Art, New York [page 91]).

Charles IV was proclaimed king on January 17, 1789. On April 25 of the same year, Goya was granted the title, Painter of the Royal Household. Thus his position as portraitist to the royal family and to the court was made secure. The painter sought to adapt himself to this role, subduing his temperamental rudeness and trying in his own way to "maintain a determined idea and preserve a certain dignity which man must possess." Overwhelmed with work, since he had to paint rapidly many portraits of the new monarchs, Goya sought to escape little by little from his obligations to the Tapestry Manufactory. This he did to such an extent that the official records for 1789 note only a single cartoon by Goya, the very beautiful *Blindman's Buff*. The *Portrait of Juan Martín de Goicoechea* is apparently of this same year. For stylistic and historical reasons the following portraits may also be considered contemporary: *Ceán Bermúdez* and *The Wife of Ceán Bermúdez*, the bullfighters *Pedro Romero* and *Costillares* (Taft Museum, Cincinnati), *The Marquis of Bajamar* and *The Marquise of Bajamar*, *The Countess of Casa Flores* (Museum of Art, São Paulo), and *Luis de Urquijo* (Academy of History, Madrid). The masterpiece of this period is the portrait *The*

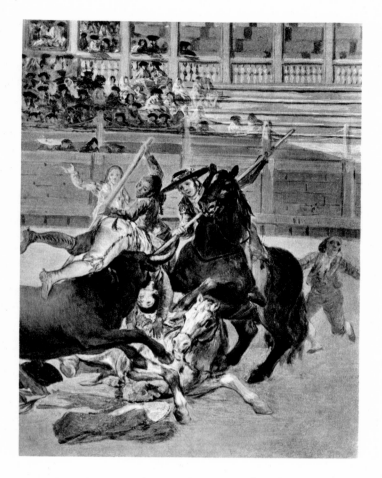

22. DEATH OF A PICADOR. *c.* 1788. Oil on tin plate, 16⁷/₈ × 12¹/₄″. *Collection Cotnareanu, New York*

Duke and Duchess of Osuna with Their Children (page 93), a symphony in grayish-blues and one of the best Goya paintings in the Prado; it is completely original, and in it Goya approaches the misty textures of Murillo, reflected in modern times by Renoir. Between August and October of 1790 Goya was in Valencia, where he was made a member of the Academy of San Carlos. While there he apparently also painted some portraits, among them the *Joaquina Candado* at the Museum of Fine Arts in Valencia. From Valencia, Goya passed to Saragossa, where he painted the portrait of his faithful friend, *Martín Zapater*.

When trying to place in order all the Goya paintings, one observes a tendency to construct various series of compositions, interrelated in subject, format, and technique, since each group would have been created within a short period of time. This predilection for building series results from various factors common to several examples of Goya's art: (1) an innate

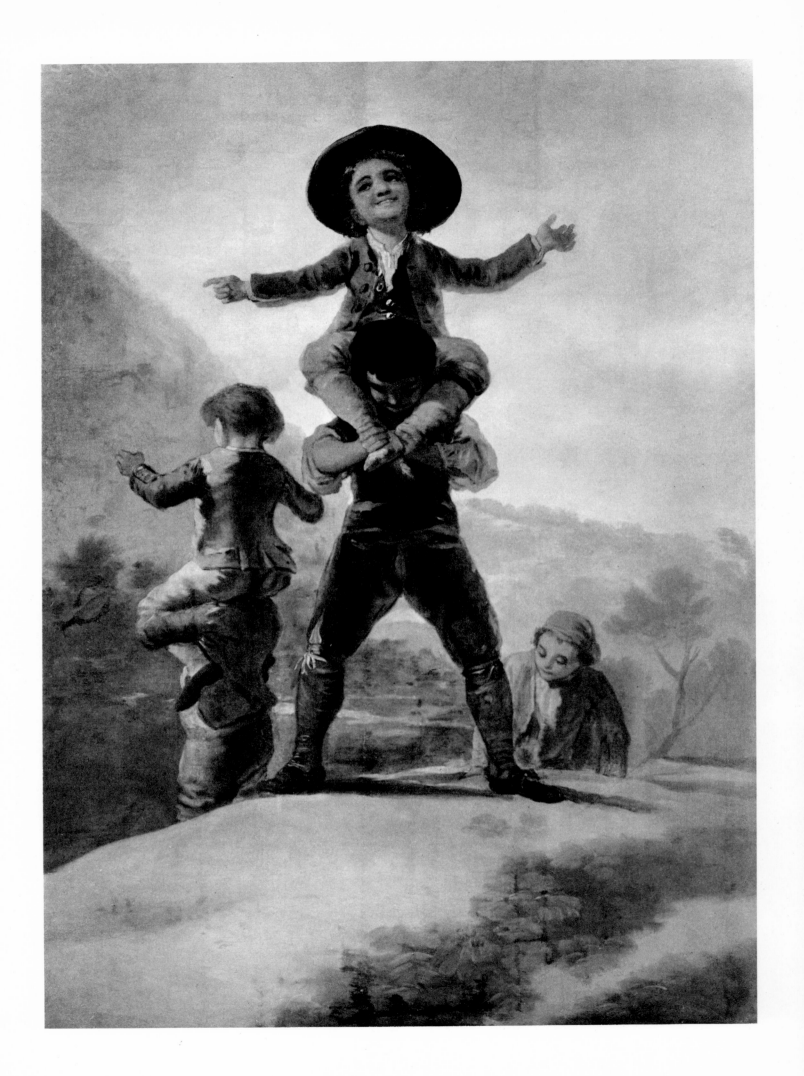

narrative tendency based in popular tradition and in medieval art, perhaps strengthened by Hogarth's examples that were possibly known to Goya through prints; (2) an attraction for the general, human element, always conceded as much importance by Goya as the strictly aesthetic; and (3) an economic motivation, which also turned Goya toward etching and lithography. Within the format of the series, Goya found the most fitting application of his descriptive talent, which united the dramatic and the satiric, the realistic and the imaginative.

Diverse childhood scenes are the subject of what, on the basis of stylistic analysis, is regarded as Goya's first pictorial series. Curiously, this series supports our thesis concerning Goya's economic motivations, since the scenes are repeated in other parallel series—truly replicas—each composition coinciding to such a degree that all must have been obtained through following a single set of drawings. The most complete group consists of six compositions (Collection Duke of Santa Marca, Madrid). The subjects include *The Swing, Playing at Soldiers, The Robbery of the Nest, Playing at Bullfighting, Children Begging Money,* and *Children Jumping.* The technique coincides with that of the tapestry cartoons of 1786; especially useful for comparison is the 1786 cartoon *The Harvesters,* which includes children together with farm workers. Architectural settings in the background provide the only reference to space and surroundings.

The same unity of theme and format is present in a group of pictures based on a Spanish subject par excellence, bullfighting. The subject is one that lends itself exceptionally well to treatment in a series. The group is comprised of seven known compositions: *Capture of a Bull, The Banderillas, The Bullfighters' Troupe Clearing the Ring, Fighting with the Cape, Death of a Picador* (figure 22), *The Killing,* and *The Dragging Away of the Bull.* The first two scenes take place before an enclosure improvised with a barrier; the other five show the inside of a bull ring with rows of seats and galleries.

OPPOSITE: 23. PLAYING AT GIANTS. Delivered in 1791.
Tapestry cartoon, oil on canvas, 54 × 41″.
The Prado Museum, Madrid

24. THE LAST SUPPER (detail). *c.* 1792.
Oil on canvas. *Santa Cueva, Cádiz*

The technique of these paintings matches that distinguishing the tapestry cartoon sketch inspired by *The Meadows of San Isidro.* We may therefore consider the bullfights to be of about 1788. Multitudes are suggested by summary brush strokes, not specific in definition of forms but very precise in distribution and tone. Chiaroscuro is rendered with a certain exactness, above all in the modeling of the figures occupying the arena. An increased interest in tactile qualities is noticeable, heightened by the contrast between the lustrous skin of the bulls and the rich ornamentations of the bullfighters' costumes. In the *Death of a Picador,* repertorial accuracy and improvisation are apparent. This feature is later developed by Goya in paintings like *The Fight Against the Mamelukes.* Noticeable in almost all paintings of the bullfight series is a certain preciosity characteristic of the miniaturist. In the series, Goya gave full expression to the aphorism coined by him: "My brush must not see more than I."

25. THE SHIPWRECK. *c.* 1793. Oil on tin plate, $18^1/_2 \times 12^3/_4''$.
Collection Marquis of Oquendo, Madrid

26. BANDIT STABBING A WOMAN. *c.* 1793. Oil on canvas,
$16^1/_2 \times 12^5/_8''$. *Collection Marquis of La Romana, Madrid*

Goya's work for the Tapestry Manufactory did not cease completely until 1791, after the delivery of seven final cartoons. Some of these, such as *The Scarecrow*, have become famous more for their themes than for their quality. They are surpassed by others less well known, for example, *Playing at Giants* (figure 23), a work that measures up to the best produced by Goya during this period of unqualified success. The painter's life and work during 1792 remain somewhat unclear. The only painting certainly of this date is the magnificent *Portrait of Sebastián Martínez* (page 95), painted in a range of bluish-grays almost identical to those again used in one of Goya's last canvases, the admirable *Milkmaid of Bordeaux* (page 163). It may be that the Martínez portrait was painted during Goya's stay in Cádiz. Goya's trip to this seaport in Spain's Southwest was motivated by his work on three large canvases, depicting scenes from the life of Christ, for

the Cádiz Oratory of the Santa Cueva. The extended format of the paintings was the source of multiple pictorial difficulties, which Goya resolved, however, with his habitual, and always surprising, originality (figure 24).

It is known that in January, 1793, Goya was granted permission to go to Andalusia to recover his health. He had been in Cádiz, apparently in Martínez's home, when the unfortunate illness that brought him near death overtook him. Slightly later, Zapater speaks of Goya's disease in a letter to Sebastián Martínez; a letter by Martínez, dated March 19, stipulates that Goya's illness was localized in the painter's head. Goya recuperated slowly from this unidentified affliction that, according to the painter's later statements, produced great noises in his head; what is certain, however, is that when the illness abated, Goya was left totally deaf.

Gómez Moreno has pointed to Goya's illness in Cádiz as one of the crises that imposed character on the painter's life and work. The deafness, which from then on limited his contact with the human world, both accentuated his propensity for the fantastic and prodded his tendencies toward the dramatic and the visionary. Goya himself says this in the famous letter to Bernardo de Iriarte which accompanied eleven pictures presented to the Academy in 1794. Actually, it is not known which of Goya's paintings at the Academy were those executed, in his own words, "to occupy my imagination, vexed by consideration of my ills, and to . . . make observations that normally are given no place in commissioned works where caprice and invention cannot be developed." The difficulty of specifying a chronology for Goya's work solely on the basis of stylistic analysis is well recognized. Nevertheless, for technical reasons, we may place a series of small paintings among the first works painted by Goya after illness had affected his imagination. Almost identical in format and size, they are devoted to representations of catastrophes: *The Shipwreck* (figure 25), *Bandits Attacking a Coach*, and *The Fire* (page 97).

Stylistically related to *The Fire* is a small panel depicting *Comedians at a Fair*, and a series dedicated to the outrages of brigands (figure 26), now in various Madrid collections. The luminous contrasts of these minutely executed works tend to dissolve all linearism; thus they already correspond to the full-blown Goyesque manner. In effect, these paintings not only renounce line completely, but also remove the focus on depth, substituting an ambience detailed by flashes of light and shade enveloped in mist. Goya manages luminous spots and reflected lights with such intuition that impressions of volume, distance, light, and movement remain in perfect harmony with the emotion and feeling of the subject. Much more is suggested than actually appears. At certain points, very notable plastic values successfully achieve with relatively dense modeling an almost academic shaping of form.

Judged by their technical simplifications, four paintings of the same type that are part of another series are somewhat later. The titles by which they are known are: *The Devil's Lamp* (National Gallery, London), *Witches in Flight* (Ministry of the Government, Madrid), and two scenes of *The Witches' Sabbath* (page 99). Goya here expresses the imminence of his visions and the spectral ambience. Despite simplifications of form, he maintains an extreme realism, made more pointed by the contrasts offered by specific deformations and very terrifying faces. It is recorded that the Duke of Osuna paid Goya for these paintings in 1798, but they were certainly painted some years earlier. We believe that the small self-portrait formerly in the Pidal Collection, Madrid, reveals with impressive truthfulness the debilitated face of Goya during these

27. TWO POETS (detail from THE ALLEGORY OF POETRY).
c. 1797. Oil on canvas. *National Museum, Stockholm*

29

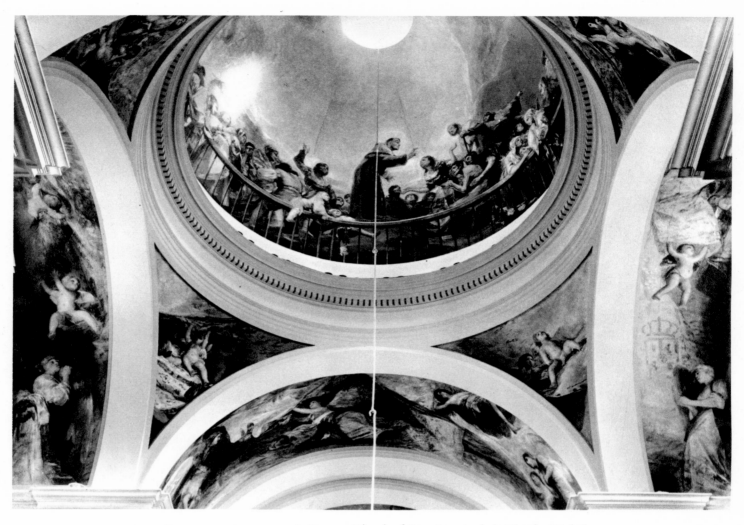

28. WALL PAINTINGS. 1798. Fresco. *Church of San Antonio de la Florida, Madrid*

months of despondent dreaming. Goya later gave the portrait to the Duchess of Alba, who still had it in her possession at her death in 1802.

The works of the affected imagination, executed in the long hours of loneliness, were followed by Goya's return to the public life of the court. By July, 1793, he was again attending meetings of the Academy. The only portrait dated in this year is that of *Caveda*. Of the following year, 1794, are the portraits of the actress *"La Tirana"* (Collection March, Palma de Mallorca, and Academy of San Fernando, Madrid), and *Ramón Posada y Soto* (M. H. de Young Memorial Museum, San Francisco, Kress Collection). Portraits, probably also of this year, are *Pérez Estala* (Kunsthalle, Hamburg), *General Ricardos* and *Tadea Arias* (Prado Museum, Madrid), and that of *Judge Altamirano* (Museum of Fine Arts, Montreal)—all executed with

complete control of a new technique. The impressionism obtained with misty blues, which appeared in portraits preceding Goya's illness, was partially renounced in order to reinvestigate the linear element used in specifying the features psychologically. This factor is augmented by the tactile value of certain elements, thus establishing a variety of qualities with an equilibrium that is always surprising when analyzed, though it is absolutely logical on contemplating the image from the aesthetic viewpoint. It is a technique of rapid brush strokes, with a very fluid medium that glides on a hard, brilliant preparation perfectly covering the grain of the canvas. Black is generously used, though without close mixing with any color; it results in a grayed tonality in the total conception.

Francisco Bayeu, with whom Goya had made his peace—as is shown by the extraordinary "gray" por-

30

trait of him (Prado Museum)—died in 1795. Goya succeeded him as director of the Academy's Division of Painting. Physically recuperated, Goya now begins one of the most brilliant periods of his career. It was probably at this time that his relationship with the Duke and Duchess of Alba began, and with it emerges one of the most debated topics in the story of Goya. It is evident that when he entered the intimate circle of this great ducal house, Goya was not the provincial genius who had portrayed the family of the Infante Don Luis. Nor was he the self-conscious and proud painter whose works were admitted with discreet cordiality into the house of the Osunas. He was, in fact, a man who had suffered and who was without any consolation other than his art. He would be welcomed with admiration and affection by the Duchess

Cayetana (Alba), then the central figure of Spanish aristocracy, who was envied by the queen herself and admired by all for her beauty and her personality. Goya's paintings that relate to the duchess are a full-length portrait of the duke (Prado Museum, Madrid) and one of the duchess (Liria Palace, Madrid), both of 1795; and small, humorous scenes with the duchess, her elderly duenna, and the two children who lived under her protection, María de la Luz and Luis de Berganza. The scenes show Goya's affectionate relationship with the house of Alba.

In August of the same year, a letter to Zapater mentioned, with ironic coarseness, a visit paid by the duchess to the painter's studio. In 1797, Goya stayed in Sanlúcar, where the duchess lived following her husband's death in June, 1796. At Sanlúcar, Goya made many drawings of the widow in his sketchbooks, and it was there that he painted the famous portrait in which she appears dressed in mourning (frontispiece). In this portrait, the duchess wears two rings, one with the name of Alba and the other with that of Goya; moreover, in the lower part, there may now be read, like writing in the sand, the inscription, "*Solo Goya*" ("Goya only"), uncovered recently after X-ray examination though previously covered with old repainting. Slightly later—at an unspecified date—Goya composed on one of the unused plates of his *Caprices* series a complete composition evidently alluding to the real or imagined duplicity of the duchess. This meaning is made clear in the inscription, "*Sueño de la mentira y inconstancia*" ("Dreams of falsehood and inconstancy").

Having examined all of this evidence, and given the physical condition and character of the protagonists, it is difficult to accept the existence of a love shared by both. That the cited portrait of the widowed duchess did not leave Goya's hand must be taken into account; he had it in his house in the inventory of 1812 and left it to his son. Therefore, the compromising names on the rings and the obliterated postscript, "*Solo Goya*," could have been added later, without the knowledge of the duchess. The etching deleted from the final edition of *The Caprices* corroborates the existence of a strong feeling on the part of the artist, a feeling not reciprocated by the duchess. In any event, after the

29. SELF-PORTRAIT. 1800.
Oil on canvas, 24³/₄ × 19¹/₄". *Goya Museum, Castres*

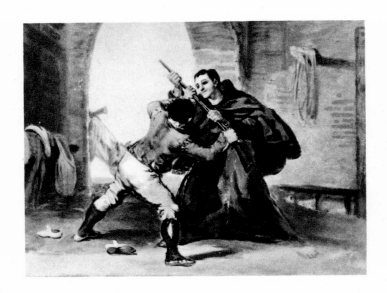 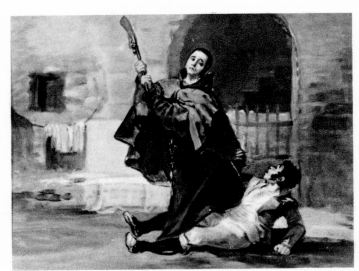

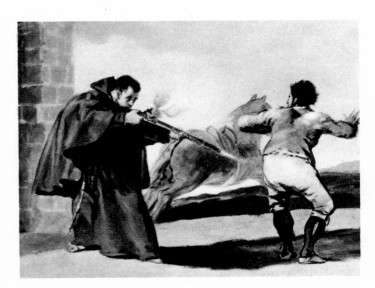 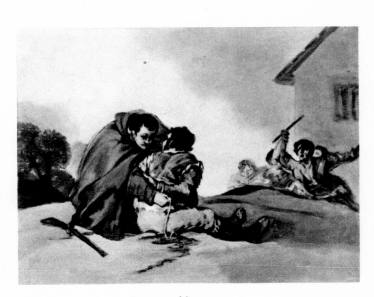

30. CAPTURE OF THE BANDIT MARAGATO BY FRAY PEDRO DE ZALDIVIA (six panels). 1806–7.
Oil on wood, each panel 12¼ × 15″. *The Art Institute of Chicago*

duchess' death in 1802, Goya began—though he did not complete—a project of paintings for the decoration of her tomb.

Modern critics do not accept the identification of four small panels at the Academy of San Fernando—*The Procession of the Flagellants, Bullfight, Inquisition Tribunal,* and *The Madhouse* (page 107)—as representing those alluded to in the cited letter to Iriarte. In effect, the technique of these four justly celebrated compositions is later than that of the groups of grossly imaginative paintings described in the preceding paragraphs. Formal precision has been radically replaced by an impressionism of vigorous daubs executed with a very fluid medium. A black tonality has completely invaded the entire terrain, altering its hues by its insistent juxtaposition. The technique coincides positively with that of the often-reproduced *Burial of the Sardine* (Academy of San Fernando, Madrid), and indicates a direction that would be seen in the future, not only in the so-called black paintings of the Quinta del Sordo, but also in the majority of compositions and portraits of relatively free execution. This is a quality that imposes character on Goya's works; further, it is a factor that must always be considered in suggesting, by means of stylistic analysis, a chronology for Goya's undated paintings. Works that are technically closest to the four small Academy panels are Goya's sketches (Lázaro Museum, Madrid) for some altar paintings, which, in 1801, Jovellanos saw in the Saragossa Church of San Fernando en Monte Torrero. Therefore, this date—1801—is proposed as the latest possible for the execution of these paintings that constitute one of the most interesting groups in the stylistic evolution of Goya.

Several portraits are dated in 1797: *Bernardo de Iriarte* (Museum of Fine Arts, Strasbourg), *Juan Meléndez Valdés* (Spanish Bank of Credit, Madrid), *Martín Zapater,* etc. They confirm the persistence of a technique that successfully achieves its maximum potential in two undertakings that break the monotony of studio works: the decoration of Godoy's palace and the frescoes of the Madrid Church of San Antonio de la Florida. As for the palace decorations, the elements of which they were comprised are not specifically known. The large medallions executed in 1797 for the *perron,*

or outer entry, remained in place until fairly recently; they represented allegories of Commerce, Industry, and Agriculture (Prado Museum, Madrid). The two large compositions, *Spain, Time, and History* and the *Allegory of Poetry* (detail, figure 27), also belonged to the decorations. These exceptional works, though obscured by successive repaintings suffered during their lengthy and unfortunate travels, have regained their pristine quality in recent cleaning (page 101). Also from Godoy's collection are the two famous *majas, The Maja Clothed* and *The Maja Nude* (pages 109 and 111), which are clearly of the period now under study.

The year 1798 is one of the most productive of Goya's career. Even judged from only what is known with absolute certainty, Goya's capacity for work is almost unbelievable. In addition to a normal number of portraits—including *Jovellanos* (Collection Duke of Las Torres, Madrid), *Camarón* (Collection Contini-Bonacossi, Florence), *Ferdinand Guillemardet* (The Louvre, Paris), and *Doctor Peral* (page 103), etc.—Goya painted *The Taking of Christ* in the sacristy of the Cathedral of Toledo, and the frescoes of the Church of San Antonio de la Florida (figure 28 and page 105). The proven fact that in its entirety this latter decoration was painted by Goya's own hand between August and November fully justifies what has been said concerning the extraordinary faculties of the artist.

Apparently, the monarchs finally realized Goya's worth; they granted him the longed-for title, First Court Painter. In 1799, the superb portraits of *Charles IV* and his queen, *María Luisa* (Royal Palace and Prado Museum, Madrid), were rendered. A good number of additional portraits were also executed, among them *The Marquis of Bondad Real* (The Hispanic Society of America, New York), *The Marquise of La Merced* (The Louvre, Paris), *Leandro de Moratín* (Academy of San Fernando, Madrid), *The Marquis of Villafranca* (Prado Museum, Madrid), *General Urrutia* (Prado Museum, Madrid), and others. This year, 1799, also saw the publication of *The Caprices,* a series of etchings to which Goya had devoted many years; they are discussed under Goya's Prints, page 51.

Goya's most important painting of 1800 was the large *Family of Charles IV.* In this family portrait, the

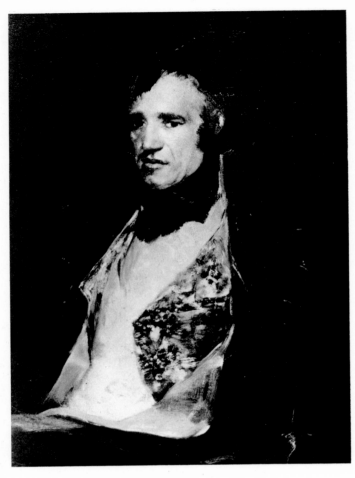

31. PORTRAIT OF PEDRO MOCARTE. *c.* 1807. Oil on canvas, 29⁷/₈ × 22″. *The Hispanic Society of America, New York*

confronted him with pain and tragedy. In 1801, Goya portrayed Godoy, the monarchs' favorite administrator, in a full composition that richly surrounded the sitter with narrative and realistic details referring to the war with Portugal (Academy of San Fernando, Madrid). The lighting is very correct and natural, and the sky shows great richness of tints within limited contrasts of tone. Of the same date are the portraits *Antonio Noriega* (The National Gallery of Art, Washington, D.C., Kress Collection), *The Architect Isidro González Velázquez*, *The Marquise of Lazán* (Collection Duke of Alba, Madrid), etc. Of 1803 are the portraits of *The Count of Fernán Núñez* (page 119) and of his wife; indicated in both is an unusual interest in clarity of contours and strength of line. A vigorous finish, satisfactorily tactile, suggests an accentuated naturalism.

The gallery of portraits of 1804 includes several of certain date: *The Marquis of San Adrián* (Navarra Museum, Pamplona), *The Marquise of Villafranca* (Prado Museum, Madrid), the *Garcini* couple (The Metropolitan Museum of Art, New York), and *Alberto Foraster* (The Hispanic Society of America, New York). Ascribed by critics to this same time are several portraits which are not dated: *The Countess of Haro* (Collection Bührle, Zurich), *The Marquise of Santiago* (Collection Duke of Tamames, Madrid), *Juan de Villanueva* (Academy of San Fernando, Madrid), *The Bookseller of Carretas Street*, etc.

The 1805 portrait *Félix de Azara* (Provincial Museum of Fine Arts, Saragossa) displays a certain density of impasto and a clarity in the representation of details. Also of this year is *The Marquise of Santa Cruz*, of which Goya painted two versions, both presenting the attributes of Euterpe (Collection Valdés, Bilbao, and County Museum, Los Angeles), and the extraordinary *Isabel Cobos de Pórcel*. In the latter, intensified plastic qualities serve a model of exceptional personality; the splendid harmony between the green of the background and the golden ocher tone, which dominates in the figure, is particularly outstanding. The figure itself is vividly drawn, and exhibits resplendent flesh tones (National Gallery, London). The dominant interest Goya always gave to the human elements is most thoroughly accomplished in the

royal figures seem fashioned without concessions of any kind (pages 113 and 115). As was Goya's usual procedure for commissioned portraits developed in the sitter's absence, admirable and lively studies from the model were painted first, in very rapid studio sessions, for each of the figures in the final group portrait. Following the example of Velázquez, who portrayed himself in *The Maids of Honor*, Goya included himself in the background shadows behind the royal family. Although this self-portrait is simply a head executed with very light strokes, Goya in addition painted a conscientious study, the exceptional *Self-Portrait* at the Castres Museum (figure 29). In the so-often modified chronology of Goya's work, this self-portrait remains definitely fixed in date. Also of this year is the portrait of Godoy's wife, *The Countess of Chinchón* (page 117).

A period of tranquillity and well-being then began in Goya's life, lasting until the war of 1808 again

portrait genre. Among the most successful of the year now under study, 1805, is that of Goya's son, Javier. In this portrait of his fine and elegant son, Goya disclosed all the desires of his spirit, both as a painter and as a father. The portrait was executed on the occasion of the marriage of the great painter's only heir; it has a worthy mate in the admirable *Portrait of Gumersinda Goicoechea*, Javier's young wife (Collection Noailles, Paris). On this occasion, Goya also portrayed other members of the bride's family, in small oils on copper (Collection Salas, Madrid, and Rhode Island School of Design, Museum of Art, Providence). Other portraits of the same year are *Leonor Valdés de Barruso* and *Vicenta Barruso de Valdés* (Collection O'Rossen, Paris), *Tadeo Bravo del Ribero* and *José de Vargas Ponce* (Academy of History, Madrid), and, perhaps, *The Marquises of Castrofuerte* (Museum of Fine Arts, Montreal), extraordinary for its synthesizing quality.

The series of six paintings in cinema-like sequence dedicated to the capture by Fray Pedro de Zaldivia of the bandit Maragato corresponds to the years 1806–07 (figure 30). In this series, there is a change with respect to earlier series. The scene is constructed from a very close viewpoint, the figures thus acquiring monumentality; details are unqualifiedly simplified. Also painted were the portraits of *Isidoro Maiquez* (Prado Museum, Madrid), *Pedro Mocarte* (figure 31), *The Marquis Caballero* (Museum of Fine Arts, Budapest), *The Count of Teba* (Frick Collection, New York), *Sabasa Garcia* (page 143), and others.

1808–28

For ten years Goya had enjoyed an evenly balanced life. He had achieved precisely what he always had sought, since his infancy and early youth. He was Spain's first painter, and, in spite of his deafness, he maintained a constant relationship with rulers and the nobility. He was rich, though he lived modestly; worries concerning the phantom of poverty lay dormant under the warmth provided by savings well invested. He was called *Don Paco el Sordo* (Frank, the Deaf Man), and people admired him; painters unconsciously broadened his stylistic orbit. But the deliberately paced evolution of the Goyesque genius was altered in 1808 by the Napoleonic occupation of

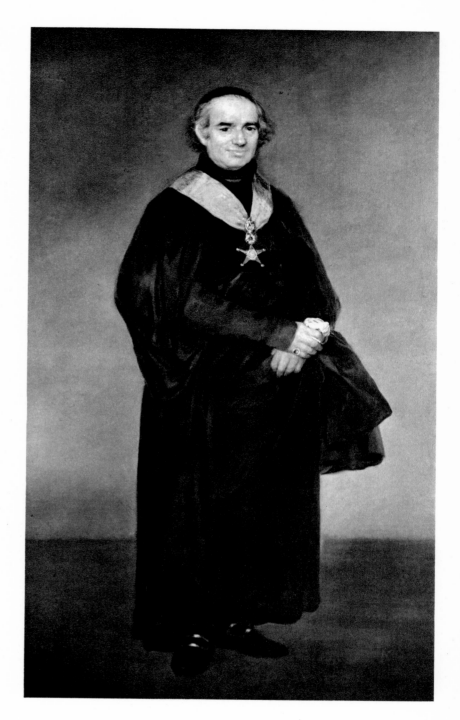

32. PORTRAIT OF JUAN ANTONIO LLORENTE. *c.* 1811. Oil on canvas, 74³/₄ × 45″. *Museu de Arte, São Paulo, Brazil*

Spain. The life of the nation was transformed with tempestuous agitation and a rapid succession of tragic events. On March 18, insurrection at Aranjuez caused the abdication of Charles IV, imprisonment of Godoy, and the proclamation of Ferdinand VII as king. Four days later, Murat peacefully entered Madrid at the head of the French army. Goya was commissioned by the Academy to paint an equestrian portrait of the

new monarch (Academy of San Fernando, Madrid); it was executed in two rapid sessions on April 6 and 7, three days before Ferdinand left for Bayonne, not to return until after the occupation.

The people of Madrid were not slow in reacting against the Napoleonic intrusion. On the second of May, right in Madrid's central Puerta del Sol, a detachment of mamelukes was attacked. The consequent brutal repression, with multiple shootings on the night of May 3, inflamed the guerrillas, who stained Spain with blood for more than four years. However, Madrid recovered an apparent normality; many Spaniards in the city accepted hopefully the arrival of the French spirit of reform. It seems that Goya, though censorious of the abuses and cruelties of the occupation army, did not react as the majority did against all that represented French influence. He was certainly a friend of the so-called *afrancesados* ("Spanish sympathizers of the French"), who cooperated and assumed direct control during the ephemeral reign of Napoleon's brother, Joseph I. Between October and December of 1808, however, Goya was in Saragossa, painting and sketching scenes of the battle led by General Palafox against the invaders. These paintings were shortly thereafter destroyed by French bayonets of the same expedition. On returning to Madrid, Goya continued to paint portraits, among them two dated 1809, *General José Queralto* (Collection Haberstock, Berlin) and *Minister José Manuel Romero* (Nelson Gallery–Atkins Museum, Kansas City, Mo.). In 1810, he painted the portraits of *General Nicolás Guye* and his nephew *Victor* (National Gallery of Art, Washington, D.C.). Goya continued as court painter, rendering an allegorical composition with the portrait

33. SOLDIERS SHOOTING AT A GROUP OF FUGITIVES. *c.* 1809–12. *Oil on canvas, 12⅝ × 22¾". Collection Marquis of La Romana, Madrid*

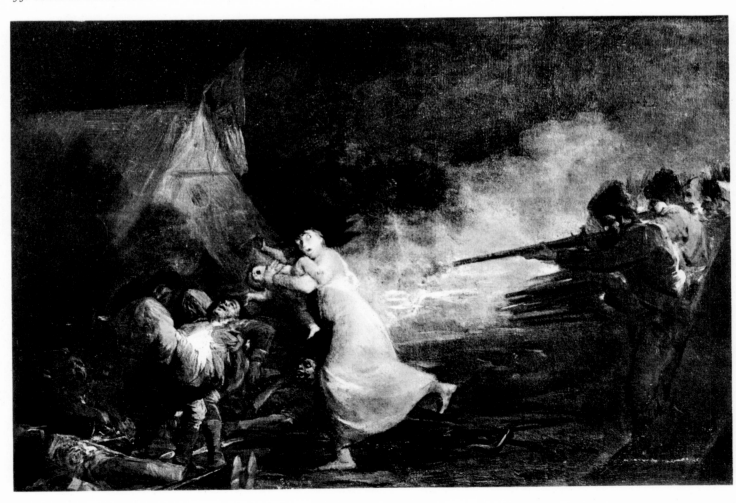

of the intrusive King. This *Allegory of the City of Madrid* (page 121) has had various titles, and is also known popularly as *"The Second of May."* Full of color subtleties, this allegory maintains a very close relationship with the previously mentioned *Spain, Time, and History*. Portraits followed, including the masterful rendering of the actress *Antonia Zárate* (Collection Beit, London), of 1811. One of the most extraordinary of nineteenth-century portraits, that of the ecclesiastic *Juan Antonio Llorente* (figure 32 and page 123), is probably also of 1811.

Since the war continued to exhaust the nation, Goya had few commissions in 1812. Certainly it was for this reason that he decided to paint the large *Assumption of the Virgin* for the parish church of Chinchón, governed by his brother, Camilo. It is a very original work, well apart from tradition in Spanish religious painting. However, it is perfectly logical, if it is regarded as a highpoint in Goya's stylistic development, beginning with the Fuendetodos reliquary and closing with the cupola paintings for the church of San Antonio de Florida. During this period, Goya was already working on a series of prints not finished until some time later, *The Disasters of War* (see figures 63–70). But work sufficient to accord with the feverish activity of a man like Goya is still lacking for this period. Therefore, it does not seem unreasonable to attribute to these years of social unrest some of the works mentioned, together with the paintings of war, in the testament of Goya's wife, whose death occurred on June 20, 1812. The inventory of her possessions, published and cleverly commented on by Sánchez Cantón, provides a record of considerable interest for learning about Goya's mode of living.

In addition to descriptions of furniture and clothing, mention of a large number of jewels reveals an instinct for investment in secure items. The inventory also contains a valuable account of paintings owned; among these appear works by Velázquez, Tiepolo, and Correggio, in addition to seventy-three by Goya's own hand. The portrait of the Duchess of Alba in widow's garb—noted in the preceding section—is included. Other paintings mentioned are: the portrait of the bullfighter *Pedro Romero*; the series concerning the bandit Maragato, already noted; two canvases

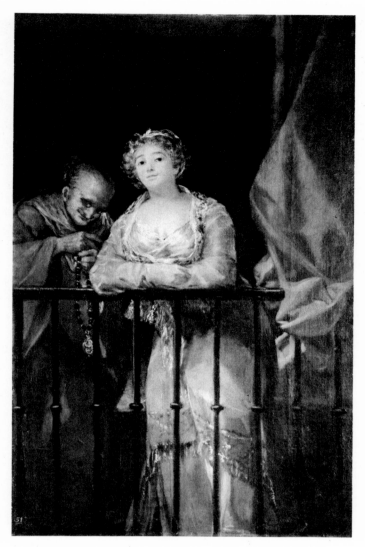

34. THE MAJA AND CELESTINA. *c.* 1809–12. Oil on canvas. $65^1/_8 \times 42^1/_2$". *Collection March, Palma de Mallorca*

of *The Majas on a Balcony; Two Drinkers; The Water Seller* (page 127); and *A Knife Grinder* (page 125). The last three must be those now in the Budapest Museum.

There were also listed: *The Weavers*, published by Mayer; twelve *bodegones* ("still lifes"); twelve pictures with the subject *Horrors of War;* and *The Colossus*. The relatively high evaluation assigned in the inventory to the twelve war scenes makes it unlikely that these were the small Goyas of the same subject now extant. On the other hand, one of them could be the impressive canvas in which a group of soldiers fires on an encampment (figure 33). The last work cited in the inventory could be the Prado's canvas presenting the disordered flight of a multitude before a gigantic figure looming in the distance (page 129). Its evident allusion to war

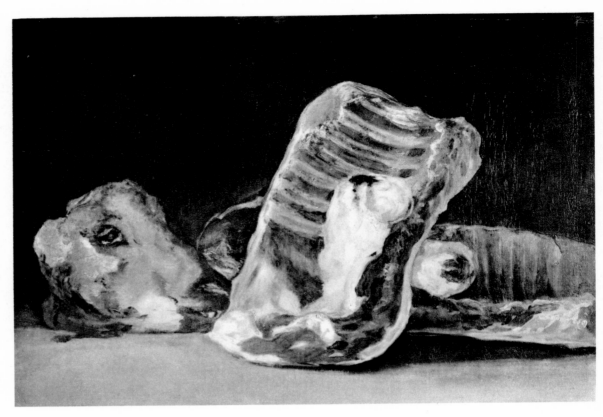

35. STILL LIFE WITH
THE HEAD OF A LAMB. Before 1812.
Oil on canvas, 17³/₄ × 24³/₈″.
The Louvre, Paris

dates this work, and it is interesting, since it unites in technique with several paintings of bullfights and with other pictures, such as *A City on a Rock* (page 131) and *The Balloon* (Municipal Museum, Agen). In these very freely executed paintings, savage superimpositions of dense impasto appear, applied and modeled with the spatula or with the double-pointed reed that was mentioned in statements by Goya's son some years after the artist's death.

The *Majas on a Balcony* (page 133) and *The Maja and Celestina* (figure 34) could be the two "Young women on a balcony" cited in the inventory. Their technique does not differ from that of works dated between 1808 and 1812, and even the themes complement each other. The first canvas represents two *majas* in full light on a balcony; a supporting role is played by two men placed in the background shadow. The second scene presents the elderly Celestina remaining in the shade, her young woman exploited to full advantage by the light falling on the balcony. Both canvases, landmarks in Goya's art, could hardly have been commissioned works. It seems to have been precisely during periods of loss of contact with his usual

clientele that Goya created, for himself, his best works. For identical reasons, the writer considers as of this period the Lille Museum's notable pair of canvases, *The Love Letter* (page 135) and *"Qué tal?"* (*"How Goes It?"*); both recall certain of *The Caprices* plates (see figures 53–62) in subject matter and spatial conception. It is always difficult, even for those accustomed to aesthetic analysis, to place Goya's extant compositions in precise chronological order when they lack both history and date.

The twelve *bodegones* mentioned in the 1812 inventory may reasonably be identified with those found in various museums and private collections, some signed and others not. These still lifes are painted with sobriety, and even their subject matter is solemn and at times surprising. One example is that from the Louvre (figure 35).

With Madrid freed by Wellington's troops in August, 1812, Goya painted the equestrian portrait of the English general (page 137). A greenish hue gives this canvas the phosphorescent glow that characterizes paintings of Goya's final period. As may be expected, military subject matter filled these years, as in sketches

38

such as *The Manufacture of Gunpowder and Cannon Balls in the Tardienta Mountains* (figure 36). Commissioned by the regency established in January of 1814, Goya painted two large canvases, the battle scene *The Second of May, 1808, at Madrid* and *The Third of May, 1808, at Madrid: The Shootings on Principe Pío Mountain* (pages 139 and 141); an extant preparatory sketch for the former canvas was painted with true freedom (figure 37). Many official portraits of Ferdinand VII, generals, and war heroes followed, including *General Palafox* (Prado Museum, Madrid) and *"El Empecinado," Don Juan Martín* (Collection Neugebauer, Venezuela).

Portraits dated in the following year indicate a return to normal existence. As always, those painted rapidly in front of the model—according to Goya's son, in a single day—alternate with full-length portraits destined for palace salons or Council rooms, where they would perpetuate the memory of political-ly or socially prominent persons. Among the first group must be mentioned two superb self-portraits (Prado Museum and the Academy of San Fernando, Madrid); a portrait, *Ignacio Omulryan* (figure 38), of impressive strength and severity; also *The Engraver, Esteve* (Museum of Fine Arts, Valencia); *José Munarriz* (Academy of San Fernando, Madrid); *Fray Miguel Fernández* (Art Museum, Worcester); and the admirable *Portrait of a Woman Dressed in Gray* (page 145), modeled with a very fine range of roses and yellows traversed with black rhythms. Typical examples of the official portraits are *The Infante Don Sebastian Gabriel de Borbón* (page 147), *The Duke of San Carlos* (page 151), and *Don Miguel de Lardizabal*, dated 1815 (page 153).

The nobility again supported Goya's studio. In 1816, he painted an ingenious portrait, *The Duchess of Abrantes* (Collection Marquis del Valle de Orizaba, Madrid), and one of great firmness, *The Duke of*

36. THE MANUFACTURE OF GUNPOWDER AND CANNON BALLS IN THE TARDIENTA MOUNTAINS (detail). *c. 1813. Oil on wood panel. Casita of the Prince, El Escorial*

Osuna (Bonnat Museum, Bayonne); a preparatory drawing and sketch for the latter are extant (Kunsthalle, Bremen). The sober portrait *Countess of Gondomar* (Institute of Arts, Detroit) would be contemporary. An enormous canvas, *A Meeting of the Company of the Philippines* (detail, figure 39), also corresponds to this period. In the opinion of the writer, the extraordinary value of this painting has not received the attention it merits; its somber tones are executed with a vigor incredible in a man of seventy, a man who had lived for twenty-four years in the enforced isolation that followed his loss of hearing. But he is now at the threshold of his most characteristic and most widely popularized artistic period. Either during or just following this year, Goya completed the etched series, *Disasters of War* (see figures 63–70) and *Disparates*

(The Proverbs). The latter, in a certain respect, is a development of the theme of *The Caprices* (see figures 53–62), which places it in a fantastic world soon to serve as the basis for the Quinta del Sordo paintings.

The documented grisaille of 1817, *Saint Isabel Caring for the Ill* (figure 40), was the last of the works executed for the Royal Palace at Madrid. Its tortured technique contrasts very clearly with the diaphanous simplicity of the *Saints Justa and Rufina*, painted for the Seville Cathedral during the same year. A single dated portrait of 1817, *The Painter Arango*, does not in any sense disturb Goya's pictorial conception. His manner of portraiture passes without explicable continuity to the blunt technique of *The Architect Antonio Cuervo* (The Cleveland Museum of Art), dated in 1819. How might we fill the intervening year? The extraordinary

37. THE SECOND OF MAY (detail of sketch). 1814. Oil on paper pasted on panel. *Collection Duke of Villahermosa, Madrid*

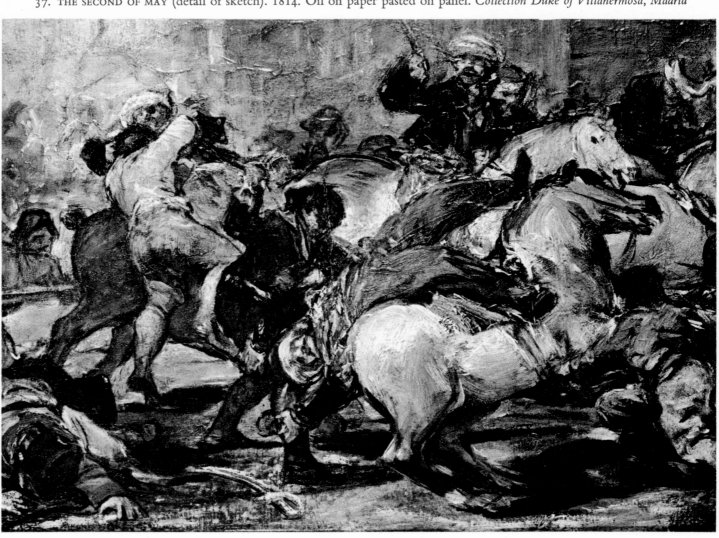

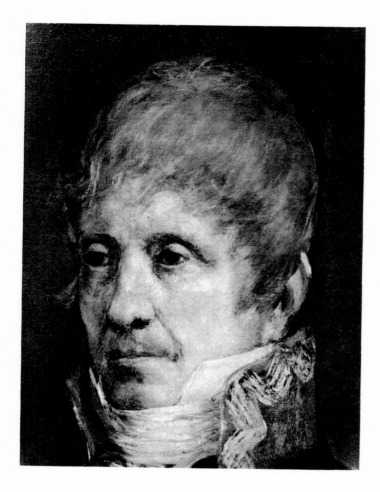

38. PORTRAIT OF IGNACIO OMULRYAN (detail). 1815. Oil on canvas. *Nelson Gallery–Atkins Museum, Kansas City, Missouri*

out the intervention of the usual pictorial instruments (figure 42 and page 149). The second is a small version, perhaps a preparatory study for the first, painted almost completely in the elastic and imperfectly ground daubed blacks that characterize the works of Goya's last years.

The date 1819 inscribed on the *Garden of Olives* and on *The Last Communion of San José de Calasanz* in the Church of San Antonio Abad, Madrid—the latter (page 157) painted between the months of May and August—simply confirms what has been said regarding Goya's technique during this period. The list of works similarly constructed might be extended by the inclusion of *The Exorcized* (Prado Museum, Madrid), and two canvases, both entitled *The Bullfight* (The Metropolitan Museum of Art, New York, figure 43, and Museum of Art, Toledo), and some others. All of the above indicate years of relative activity, but

Procession (detail, figure 41) may logically be of 1818. It is painted almost exclusively with Goya's singular spatula work, which here attains surprising qualities, based upon superimpositions and arbitrary blendings of black, white, and ocher. Other pictures of similar structure, unfortunately not well known, seem to form a series with the *Procession*. We are thus at the borders of the abstract world of quality attained by texture, to which Goya, though not entering, nevertheless opened a door. He finally arrived at the truth discovered by Titian in his old age and by Velázquez in his youth, that color is of little import; rather, what is essential in painting is tone, and above all, the balance of values.

In the same technique, and consequently of the same period, are two paintings titled *The Forge* (Frick Collection, New York, and Collection Elosúa, Bilbao). In the first, Goya constructs three life-sized, tortured figures, with blobs of black and white which at times seem designed to render the figures accidentally, with-

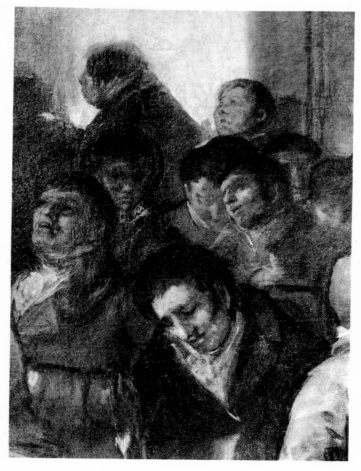

39. A MEETING OF THE COMPANY OF THE PHILIPPINES (detail) c. 1816. *Goya Museum, Castres*

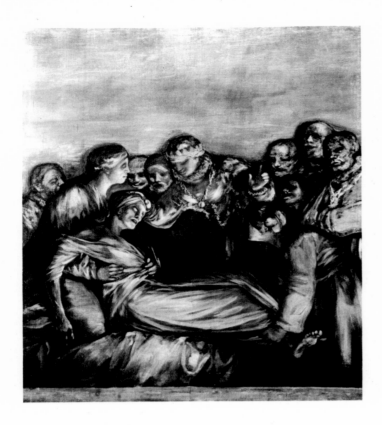

40. SAINT ISABEL CARING FOR THE ILL. 1817.
Oil on canvas, 66¹/₂ × 50³/₄″. *Royal Palace, Madrid*

also they indicate a tendency toward creating a greater intimacy, as if to suggest that Goya was breaking away from the world and his clientele of church and court. His acquisition in February, 1819, of the house in Madrid's countryside, the famous Quinta del Sordo— now destroyed—seems to confirm the painter's wishes for isolation. On April 4, he attended sessions of the Academy for the last time. From the dedication on *The Self-Portrait with Doctor Arrieta,* it is known that Goya suffered another grave illness at this time. During the painful hours of his convalescence he probably conceived the idea of the fantastic decoration of the country house, the *pinturas negras* ("black paintings"), which had entered the Prado Museum by 1882 (page 161).

In the preceding pages, repeated references have been made to Goya's preparatory sketches, which, however, have never been conceded the importance they merit, both by virtue of their grand plastic values and as a document indispensable to the proper study of the aesthetic development of this great painter. They are preserved in sufficient numbers to permit us to affirm that Goya never executed a composition or

portrait without first painting a preparatory sketch. The impressive sketch recently acquired by the Basel Museum (figure 46)—a sketch for one of the Quinta del Sordo paintings—proves that even Goya's most intimate works were preceded by a study or approximation of the final oil painting. For Goya, the process of realization of a work began with a rough sketch or preparatory drawing that served to block out the theme and place it in the space. There then followed the oil sketch, on which he occasionally worked at length, resolving problems of light, color, perspective, and composition. Next, he was accustomed to make drawings from nature, with a more academic criterion, in order to analyze details of the work. In general, there is a notably close relationship between the sketch and the final work. The foregoing leads one to believe that Goya understood the value of his sketches, and further, that he gave them a very particular importance. The artist's own observations support this idea. In 1801, he wrote in a memorandum concerning restoration: "It is not easy to retain the instantaneous and transitory design that issues from the imagination, and the accord and agreement put into the first execution, so that final retouchings give way to variations." By this Goya meant that, in his opinion, the painting, in translating the outlines and colors of the sketch to final form, lost its spontaneity and deepest emotion. Goya's own works substantiate his thesis, since the strength and beauty of his sketches equal, when they do not surpass, the interest of his finished works. This is comprehensible in the work of a painter whose genius is characterized precisely by spontaneity, boldness, and inventiveness of execution.

To judge by technique and subject matter, a series of cruel and enigmatic small paintings, reflecting the manner of the Quinta del Sordo oils, was probably begun in 1819, during Goya's period of retreat. *A Duel, Carnival Scene, Preaching Monk* (page 159), *Punishment of a Sorceress, Seated Man,* and others, are filled with a threatening atmosphere which creates an impressive psychological tension. Their sublime execution unites them with the potent *Repentent Peter* (The Phillips Collection, Washington, D.C.) and *Saint Paul,* Goya's last religious paintings.

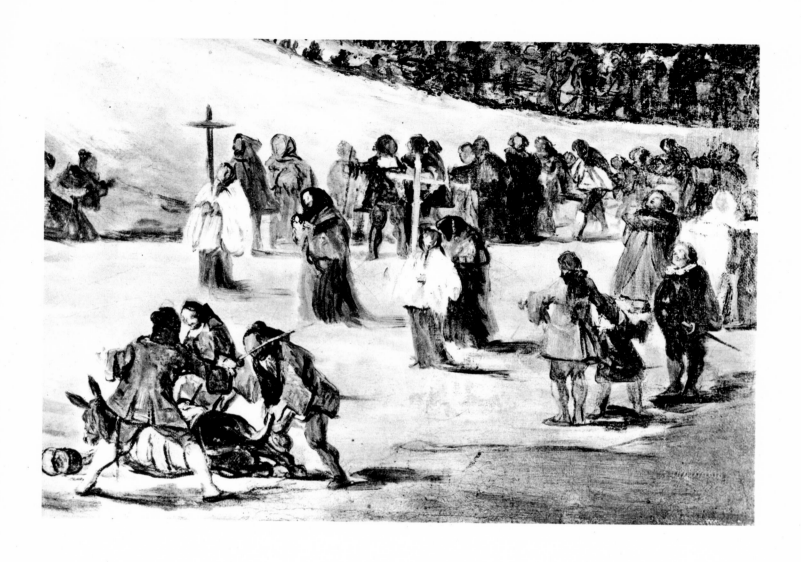

ABOVE: 41. THE PROCESSION
(detail). *c.* 1817–18.
Oil on canvas. *Collection Bührle, Zurich*

LEFT: 42. THE FORGE (detail). *c.* 1815.
Oil on canvas. *The Frick Collection, New York*
(see colorplate)

The country house was ceded to Goya's grandson, Mariano, in September, 1823. Goya, who had shown himself a partisan of the liberal constitution, feared attachment of his property as a consequence of political retaliation; Ferdinand VII, supported by the French army of the "Hundred-thousand sons of St. Louis," under the command of the Duke of Angoulême, imposed absolute monarchy. For three months Goya took refuge in the house of the priest Don José de Duaso y Latre, censor, and editor of the periodical *La Gaceta*. There Goya painted the portraits of his protector (Collection Rodríguez Otin, Madrid) and of the priest's nephew, *Ramón Satué*, a justice of the court (Rijksmuseum, Amsterdam). Still, Ferdinand VII and his counselors did not sympathize with Goya; the artist, old and pained, found things going badly in the closed atmosphere of Madrid. He officially asked for, and obtained, permission to take the cure of the waters at Plombières, France, in May of 1824. Goya first went to visit Moratín, who had sought refuge in Bordeaux. Moratín wrote the following in one of his letters: "Goya has come, deaf, old, torpid, and weak . . . but very content and anxious to see the world." The painter then visited Paris, remaining there until September. While in Paris, he painted a portrait of Joaquin María Ferrer and his wife.

Goya was installed at Bordeaux in October, living with Doña Leocadia Zorrilla and her children, Guillermo and Rosario Weiss. He again painted portraits, extraordinary for their simplicity, including *Moratín* (Museum of Paintings, Bilbao) and *María Martínez de Puga* (The Frick Collection, New York).

Goya requested an extension of the permission for absence from the court and this was granted to him in

43. THE BULLFIGHT (detail). *c.* 1819. Oil on canvas. *The Metropolitan Museum of Art, New York*

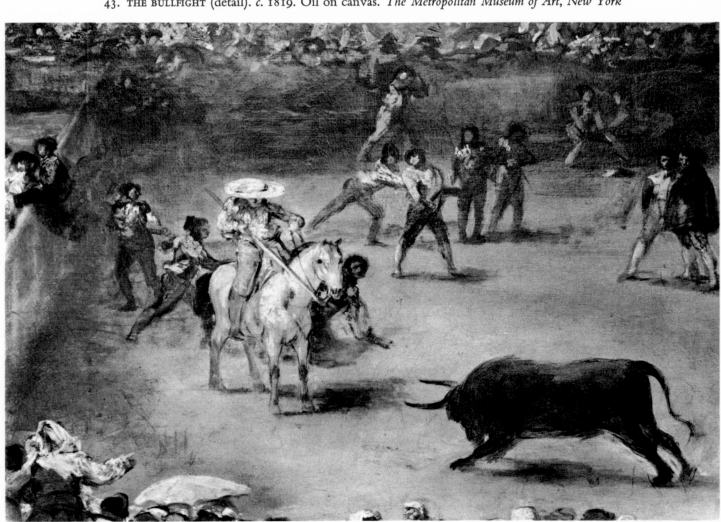

LEFT: 44. TWO HEADS. *c.* 1825. Miniature, oil on ivory.
Rhode Island School of Design Museum of Art, Providence

BELOW: 45. THE DRUNKEN MASON. 1791. Oil on canvas,
13³/₄ × 5⁷/₈". *The Prado Museum, Madrid*

June of 1825. He found it to his liking in Bordeaux, as is seen in Moratín's letters, which comment, ". . . he is very spirited and paints all that occurs to him, without ever spending time in correcting what he has [already] painted." One of Goya's preoccupations in Bordeaux was the precocious facility for drawing demonstrated by the small Rosario Weiss; certainly it was to orient the child toward the painting of miniatures that Goya himself executed a series of small oils on ivory, transcribed from his own highly imaginative drawings and realized with the technique of daubs that characterizes all the work of this period (figure 44). He also continued his experiments on the lithographic stone; justly famous are the four lithographs known as *The Bulls of Bordeaux.*

Goya returned to Madrid in May of 1826 and was apparently well received—even by the king, who ordered Vicente López to paint Goya's portrait (Prado Museum, Madrid). In every possible way, Goya sought to obtain his retirement pension; on its being granted, he returned to Bordeaux in July, accompanied by his grandson Mariano. Of the following year, 1827, are the painter's last works of true force. Some of the excellent paintings that are known include the effigies of a religious brother and a nun, *The Portrait of Juan Muguiro* (Prado Museum, Madrid), and the portrait,

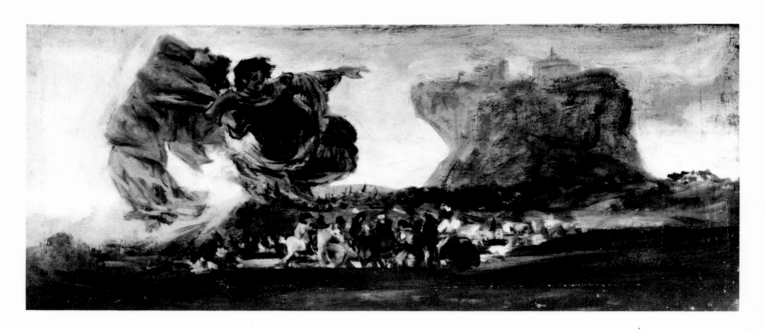

46. FANTASTIC VISION (sketch for a composition for the Quinta del Sordo). *c.* 1820. Oil on canvas. *Museum, Basel*

Mariano Goya. But the masterpiece of this final moment is the magnificent *Milkmaid of Bordeaux* (page 163). Here a new and final change in Goya's manner may be appreciated, accomplished with a more lyrical and delicate palette in union with proper moderation of the impasto. Left unfinished in 1828 is the sober and intense *Portrait of José Pio de Molina* (page 167). On April 16 of that year, the great painter died outside his native country. His mortal remains were brought to Spain in 1901, at the beginning of the century that would develop to a most unusual extreme many of the bold techniques that had appeared in his work.

BIOGRAPHICAL OUTLINE

1746 MARCH 30: Born in Fuendetodos (Saragossa province, Spain), son of Gracia Lucientes and José Goya, a gilder.

c. 1759 Apprenticed to studio of José Luzán y Martínez in Saragossa, after attending Father Joaquin's school in the same city.

c. 1760 According to tradition, Goya, as a mere boy, paints doors of reliquary cabinet for parochial church of Fuendetodos (destroyed by fire in 1936).

1763 Goes to Madrid; makes unsuccessful application for scholarship to Royal Academy of San Fernando.

c. 1763 Studies under painter, Franscisco Bayeu (1734–95).

1766 JULY: Again fails before the Royal Academy in scholarship application.

1771 APRIL: In Rome, participates in competition sponsored by Royal Academy of Parma, whose jury praises the now lost painting submitted by Goya.

1771 JULY: Returns to Spain. According to tax records in Saragossa, is established as independent painter. Produces his first known fresco, for the Cathedral of Our Lady of Pilar, Saragossa.

1773 JULY 25: In Madrid, marries Josefa Bayeu, sister of his former teacher.

1774 Called to Madrid by Anton Raphael Mengs (1728–79), German painter at Madrid Court who, at the intercession of Bayeu, invites Goya's participation in the execution of tapestry cartoons for the Royal Tapestry Manufactory of Santa Barbara.

1775 Date of Goya's earliest known self-portrait.

1775 DECEMBER 15: Baptismal date of Goya's son, Javier, in Madrid.

1776–80 Paints as many as 46 tapestry cartoons, among them the famous *Parasol, Crockery Seller, Kite, Blind Guitarist, Washerwomen*. During same period is received into court of King Charles III and given opportunity to study royal collections, particularly paintings by Velázquez.

1780 Elected Fellow of Royal Academy of Fine Arts of San Fernando, Madrid; becomes highly regarded portraitist.

1780–81 FALL–SUMMER: Again lives in Saragossa; participates in program of decoration for Council of Works of El Pilar Cathedral.

1781 JUNE: Returns to Madrid and enters public competition to obtain commission for large painting for Church of San Francisco el Grande.

1784 OCTOBER: Judged winner in above competition; first unqualified success at Madrid court.

1785 Becomes Deputy Director of Division of Painting, Academy of San Fernando, Madrid.

1786 Receives title of Painter to the King.

1788 Is unsuccessful candidate for position as Director of Division of Painting, Academy of San Fernando.

1789 Under Charles IV, becomes Painter of the Royal Household.

1790 In Valencia, elected member of the Academy of San Carlos.

1791 Concludes work for the Royal Tapestry Manufactory, Santa Barbara.

1792 Onslaught of illness that led to loss of hearing.

1793 Recuperates in Andalusia; works on series of etchings, *The Caprices*.

1793 SUMMER: Again attends meetings of the Academy; produces sketches with bullfights, carnival, and Inquisition scenes.

1795 Upon death of Bayeu, succeeds to directorship of Division of Painting, Royal Academy

1796–97 Sojourn in Sanlúcar with widowed Duchess of Alba; produces sketchbook and portraits of Duchess.

1798 In Madrid, paints panels for Church of San Antonio de la Florida.

1799 Receives title of First Court Painter.

1800 Date of magnificent painting, *The Family of King Charles IV.*

1802 Death of Duchess of Alba.

1808–12 Franco-Spanish War inspires series *The Disasters of War.*

1812 JUNE 20: Death of Goya's wife, Josefa. Extant inventory of her possessions is the source of chronological data for some of Goya's works.

1815 The series of etchings, *La Tauromaquia* (Bullfights).

1815–19 The series of etchings, *Disparates* (Proverbs).

1819 Buys the Quinta del Sordo (House of the Deaf Man), for which he paints the so-called black paintings during convalescence from another grave illness.

1823 A political fugitive, spends some months in hiding in home of a priest, Don José de Duaso y Latre; paints members of that household.

1824 Spends rest-holiday in Plombières. On return to Madrid, stops off in Bordeaux, where ultimately he resides.

1825 Receives royal permission to extend sojourn in Bordeaux; produces 4 lithographs, *The Bulls of Bordeaux.*

1826 During short visit to Madrid, resigns position as First Court Painter, receives royal pension and leave to retire in Bordeaux.

1827 Date of final masterpiece, *The Milkmaid of Bordeaux.*

1828 APRIL 16: Dies in Bordeaux; mortal remains returned to Spain in 1901.

DRAWINGS AND PRINTS

GOYA'S DRAWINGS

Only a small number of the huge quantity of drawings Goya undoubtedly made have come down to us. Nevertheless, Mayer catalogued eight hundred drawings, a figure now increased to more than nine hundred, in light of recent discoveries. Many of the drawings that remained in Goya's house at his death were collected by Valentin Carderera (1796–1880). The Prado Museum now owns a very important group of approximately five hundred Goya drawings. The Metropolitan Museum of Art in New York and the National Library at Madrid also have notable collections. Outstanding private collections include that of Gerstenberg in Berlin, most of whose drawings proceed from the old Beruete Collection. In general, the Goya drawings give us a thorough account of his multifaceted genius. They possess more boldness, if possible, than his paintings, and reveal most deeply the artist's innate expressionism. In many, narrative significance is keen and closely related to reality, as is characteristic of Spanish art. But it would not be equitable to tarry in minute consideration of the most dramatic or satirical works. Those drawings that are otherwise—those that are characterized by lyrical quality of line or richness of composition, as well as by serenity of theme and form—also deserve consideration and study.

We must begin by establishing a summary classification of the types of Goya drawings. This may best be done according to the purpose assigned to them by the artist, since this distinction permits the best understanding of the aesthetic of each, and of the feeling for the series of which they are almost always a part. Thus the following groups may be specified: (1) general sketches, executed as a first idea and directly preceding oil sketches in small format; (2) drawings done subsequent to the general sketch and preceding the final, large work, subdivided into (a) rough drafts designed to determine masses of light and shade, and (b) detailed drawings made to analyze partial figures or details of form; (3) *academias*, or studies from the nude, rare in Goya's work and stemming from a wish or need to teach such art to his pupils; (4) studies for etchings or other known prints, almost always in a series, as those of *The Caprices* (figure 50)—begun, according to Carderera, in 1793—and of *The Disasters of War* and the *Disparates*

(*The Proverbs*); and, (5) assorted drawings unrelated or in a series, probably preparatory to unrealized prints. Two self-portraits now in the Prado, a frontal view of 1795 and a later profile of Goya wearing a hat, are among drawings in this last category. Drawings of this fifth group are of greatest importance, since those related to final works achieved a definitive realization, which has caused them to become best known.

In the drawings for which no ulterior application is established, a new facet of Goya's art is offered, extremely rich in technical solutions, in formal significances, and in a very humanist iconography. The evolution of Goya as a painter is paralleled in his work as a draftsman. However, the developmental stages cannot be followed in so consistent or continuous a manner, since drawings are lacking for periods of years and even decades. There are no Goya drawings for his first period, here considered to have terminated with his establishment in Madrid in 1775. There are few dating from the second period, which ended in 1792 with the crisis of Goya's illness. Thus it is unnecessary to add that the immense majority of extant drawings correspond to the third and fourth periods of the artist's career, from 1793 to 1808 and from 1808 to 1828 respectively. This certainly cannot be accidental. Deafness, which Goya began to suffer in 1792, isolated him from society, moving him to concentrate in himself and to nourish his imagination. Thus he then enjoyed making a great many drawings, and, to turn them to economic advantage, he projected them into etchings, aquatints, and lithographs.

The earliest known Goya drawings are of the year 1777. They include preparatory studies for a series of etchings after paintings by Velázquez as well as studies for tapestry cartoons. These original works permit most adequate analysis; in them is seen the tendency toward realism of Goya's early years in Madrid, and an interest in unadorned narrative and the direct rendering of popular types. Other drawings of the same period are analytical figure studies, doubtlessly of the intermediary phase between execution of the oil sketch and of the cartoon. They are in pencil and gesso on gray paper; their dominant quality is a profound feeling for form and quality of material. Corporeal tension, volume, and attitude are shaped with an impressive truthfulness in a technique that skillfully employs both linear hatchings and gradual blendings in modeling of surfaces.

Two *academias* in the Valencia Museum are probably of 1790, perhaps executed before the pupils of the Academy of San Carlos in Valencia. One represents a nude man, his arm raised in the act of striking a blow. In pencil and gesso on gray paper, its modeling is based on very subtle gradations that fully facilitate the sense of corporeal relief; there is simultaneously a clear recognition of the quality of flesh tones. Contour lines are simply insinuated, though in places they have a slight sharpness. Shading is skillfully rendered and suggests movement together with effects of light. The second drawing differs in technique. It is executed in sanguine, and modeling is accomplished by means of parallel strokes. There is a great dynamism in the figure, which represents a fencer. Goya's final drawings frequently adapt both procedures patently exaggerated. However, hatchings create some dark expressionist masses, accentuated with the passage of time.

Before turning to the last drawings, the groups or series to which they belong must be established. These consist of (1) drawings from the two so-called Sanlúcar sketchbooks (1796–97); (2) a black- and sepia-ink series with Goya's legends and sequence numbers, executed after 1800; (3) a sepia-ink series, numbered by Goya, but without legends (1818–20); (4) black-pencil drawings numbered by Goya, without legends (1820–24); and (5) black-pencil drawings numbered by Goya, with legends (1824–28). The drawings of the Sanlúcar albums are distinguished by a particular perception of form, relative sensitivity of composition, and an india-ink wash technique with very pleasing medium dull tones and very effective, though simple, contrasts. The themes are typical—young gallants accompanied by young women, walking, courting, etc. In some, Goya's humor comes forth, as in the *Girl and Bull* (The Metropolitan Museum of Art, New York). In others, there is a dramatic sarcasm, as in the Prado's *Caricatura alegre*. These drawings correspond to the period of Goya's stay with the Duchess of Alba; the silhouette of the Duchess is recognizable in several of the drawings.

The second group is composed of a gallery of popular types—some of which appear symbolic—and of a series of shackled figures wearing the conical headgear of those prosecuted or submitted to torment. Some others present effigies in disagreeable and hardly aesthetic grotesque moments with marginal notes underlining the very

sarcastic humor of the image. Intensity of chiaroscuro is superior to that of the preceding drawings. Freedom and intention of the outlines are also more evident. Boldly inventive contours vibrate within strict realism, expressionism, and caricature-like deformation, saturated always with dramatic human content. The technique employed is that of a black wash or a mixture of black- and sepia-ink wash. Daubings model volume, but are always used to suggest horror with a demoniacal intensity. There are also, however, drawings in which beauty and serenity triumph, as the one of a feminine figure with considerably dramatized Hellenistic features and the inscription, "*Para los que están en pecado mortal*" ("For those who are in mortal sin"). Acknowledged in these drawings is Goya's analytical ability, his ability to create living beings, materials of density, and characteristic form and texture, all with only summary daubs. He achieves surprising truthfulness with minimum linear elements of diverse tonal intensity. Taut or languid contours, smooth or spirited surfaces, are captured with absolute fidelity, as are the emotions and sentiments of the characters, be they human or conceived in the intermediary zone between the allegorical and the diabolical. This last may be seen in the nude figure with the ears of an ass who "despises everything" (the *Todo lo desprecia*, from a folio sketchbook).

Exceptional in the third group are images of fencers, their movements made violent by means of intersecting diagonals. Some observers consider the ambience, defined by daubs of medium tint contrasted against the dark shades of the figures, as of greatest interest. But perhaps the culmination of Goya's art is found in the black-pencil drawings executed during the last years of his life. An exaggerated form, profoundly tragic while very simple, is united with vigorous contours, abrupt in profile—as in the boy holding his hands to his head, or in the synthesis of the human and the animal in the *Animal de letras (The Learned Animal)*. The freest imagination varies the subjects, arriving at the limits of a type of image popularized by surrealism; such is the case in the drawing titled *Gran disparate* ("great absurdity," figure 51), in which a man feeds his own severed head. The Goya drawings have been a source of inspiration for many artists of both the past and present centuries, extending from Lucas to Picasso, and including Daumier, Ensor, and Nonell, to cite only a few representative names.

GOYA'S PRINTS

Extant prints by Goya begin with three with a hagiographic theme, the only known etchings by his hand related to religious subjects. Possibly the earliest of all his prints is *The Flight into Egypt*, dating from before 1778. *The Bust of San Francisco de Paula* and a *San Isidro* are perhaps of the year during which Goya executed the series of eighteen etchings after paintings by Velázquez and Carreño de Miranda that he saw in the royal collections; in the latter are noticeable deformations and modifications of proportion with respect to the originals.

A substantial advancement over the noted series was produced in *The Caprices*, whose fame, as has justly been indicated, has come to surpass at certain moments the artist's paintings themselves (see figures 53–62). The greater part, if not all, of the eighty etchings of which this series is composed was executed by Goya in the years between 1793 and 1796. Thus we know he began to work on the plates soon after he suffered the illness that isolated him from the world by leaving him deaf. Concerning the history of the edition, it is known that Goya planned to publish seventy-two prints in 1797. Sale of the series was announced on February 6, 1799, with eighty plates specified; fifteen days later, when twenty-seven sets had been bought at a price of one ounce of gold for each, *The Caprices* were withdrawn from sale, perhaps as a result of pressure from the Inquisition. Goya offered the plates to the king for the Calcografía Nacional ("National Office of Graphic Reproduction"), on July 7, 1803. The offering was accepted on October 6, and an annual pension of 12,000 reales was granted to Goya's son, Javier, as compensatory payment.

The technique used for *The Caprices* plates was a mixed process combining etching and aquatint in uniformly flat shades, frequently very intense, particularly in background areas. Varied degrees of etching and aquatint model the clothing, figures, and accessories; areas of light were executed with the burnisher. In this way, Goya obtained effects of color and daubing much more rapidly than would have been possible with etching alone. Many preparatory drawings are known. A certain dynamism is habitually offered in the compositions, with two or more persons in the foreground and action so immediately real as to seem unreal, though always charged with interest and character. The themes vary within certain tendencies noticed also in

the master's pictorial works. Thus appear there social and moral satire, scenes of sorcery, of the gallows, etc. However, the grotesque feeling of some of the compositions is peculiar to the prints, whose marginal notes go even beyond their critical task, as for example, in the print inscribed *De qué mal morira?* (*What Will He Die Of?*; figure 59). Here an ass acts the role of doctor, taking the pulse of a man ill in bed. In some instances, the satiric or burlesque sense is not as easily discernible.

It has been said that these subjects came exclusively from Goya's imagination. Many of the prints clearly reveal a fecund and pointed imagination, in addition, to the artistic gifts and techniques of the engraver. Nevertheless, Goya could have encountered in popular prints some of the ideas that served as points of departure, just as he could also have consulted books concerning magic for his *aquelarres* ("fantastic visions"), or witches' sabbaths, and similar subjects. The most dramatic prints are those that are simplest in appearance, though in them the human being is presented with most bestial features, as in *Están calientes* (*It's Hot;* figure 55). *The Caprices*, by virtue of this constrained thematic synthesis and creative technique, have become one of the most universally known examples of Spanish art. They were reprinted from the original plates in 1799, 1806–7, around 1850, in 1868, and in various later years.

Following chronologically is the series titled *The Disasters of War*, of whose eighty-two prints only sixtyeight refer to the war. The remaining fourteen are of political or social intent, expressing Goya's liberal sentiments and justifying the fact that the artist chose not to publish them during the reign of Ferdinand VII. The theme of these admirable prints is neither the army nor the war, but rather the sufferings of man, who not only must take arms against the invaders, but also must be exposed to the most terrible repressions, tortures, and massacres. Three of the plates are dated 1810 and thus correspond to the years of Napoleonic domination. It is probable that the series was already begun during Goya's sojourn in Saragossa in 1808. Carderera, however, considers the entire series to be of the period 1810–20. With regard to technique, Goya on this occasion preferred the lively process of etching, which he strengthened by expressive retouchings with dry point. He also obtained effects of intensity by re-covering the ground of the copper plate with the dense grain of aquatint. Preparatory drawings for the majority of these plates are in the Prado Museum. As a result of the effects rendered by the described technique, form, in *The Disasters*, is more abrupt and denuded than it had been in *The Caprices*. Volumes are treated with draftsman-like intensity or stand out as clear masses against a dark background. Some of the compositions are allegorical in character, though most are like moments caught during a dramatic incident. Among the most dreadful subjects must be cited the man with his arms impaled on the pointed branch of a tree. In several of the prints, a certain spirit of fantasy is added to the narration of incidents that gives them their character. The scenes of shootings are among the most meaningful and realistic. The series remained unpublished until 1863; thereafter, editions were made in 1892, 1903, 1906, and later.

The most naturalistic Goya series, the one that adheres with closest narrative fidelity to the visual truth in most of its plates, is the *Tauromaquia*, completed in 1815. It must doubtlessly have been begun several years earlier, perhaps at the beginning of the century, as Carderera contended. Some of the prints are dated 1815 and some are signed. Goya's first idea was to illustrate with some engravings Nicolás Fernández de Moratín's *Carta histórica sobre el origen y progreso de las corridas de toros en España* (*A Historical Note Concerning the Origin and Development of Bullfighting in Spain*). Despite the realism of the series mentioned earlier, and despite the many plates representing actual events witnessed by Goya, the artist began his work with a group of prints referring to the earliest manifestations of the art of bullfighting. He wished to illustrate an activity not yet professionalized, and feats enjoyed by monarchs and nobles alike. Thus he presents Charles V spearing a bull, and includes a legendary figure like the Moor, Gazul. The technique employed in this series approximates that of *The Disasters*, with etching dominant. Intense shadows cover the backgrounds or serve as contrast to model forms. Some of the compositions are astounding for purity of drawing and originality of sense of space, e.g., the one showing a bull bearing a man on his horns toward a group of terrorized spectators. Shades are profoundly darkened in some scenes, as in the print showing dogs being thrown to the bull. Some incidents possess a dramaticism that becomes horror, like one reproducing the moment in which two men on foot spear a bull already dying.

Publication of the *Tauromaquia* was announced in the *Diario de Madrid* on October 28, 1816; thirty-three plates were included. In 1855, the Calcografía Nacional printed another edition. Still another was made in Paris in 1876 by the engraver, Loizelet, who added seven prints designated with the letters *A* to *G*: Lafuente notes the existence of four additional prints lettered *H* to *K*.

Next in order of chronology and technique is the *Disparates (The Proverbs)* series, which Carderera considered as having been executed during 1817–18. Thematically, this series forms a continuation of *The Caprices*. However, in form and procedure it approximates *The Disasters*. In all, contrasts of light and shade are systematically employed with greater intensity and virtuosity; an influence from Rembrandt is evident. Within its narrative character, drawing is less naturalistic than in other series; a general arabesque of great effect and beauty is sought, and is heightened by the mat quality of the shades. In some prints, organization of the figures discloses a kind of allegory, as in the one presenting a group of bulls linked together in a more decorative than representative formula.

The character of fantasy is less sarcastic than in *The Caprices*, and the critical sense appears more veiled. In 1850, an edition of the series was made on loose sheets. The plates were reprinted in 1864 by the Academy, and again in 1865–66, 1891, 1902, and other later years. It must be noted that, in 1877, Yriarte published four additional prints in the periodical *L'Art*.

To all that has been mentioned must be added Goya's lithographs and some loose prints of various dates. In the former group belongs *The Old Weaver* of 1819, the earliest lithograph of known date to be executed in Spain. Others are cited here either by title or subject matter: a *Duel in the Spanish Manner*, a *Hooded Monk*, a *Hellish Scene*, etc. *The Bulls of Bordeaux* is the title given to four lithographs with diverse taurine scenes drawn by Goya in Bordeaux in 1825 and printed by Gaulon in an edition of one hundred examples. Among the loose prints referred to are: *The Cloaked Man, The Maja, The Blind Singer, The Garroted Man,* and the magnificent *Seated Colossus*, all of which reiterate themes most frequent in drawings by the great artist.

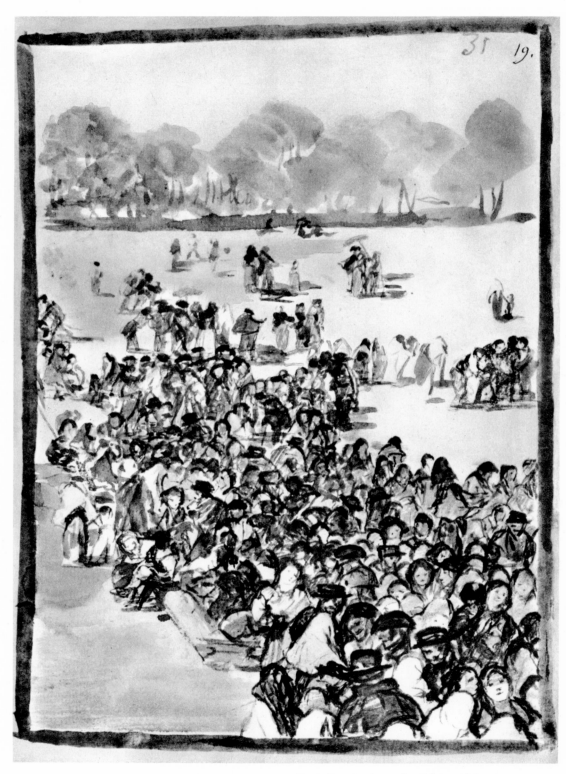

47. CROWD IN THE MEADOW. *c.* 1819. Drawing, sepia wash, $8^1/_8 \times 5^5/_8''$.
The Metropolitan Museum of Art, New York

LEFT: 48. LUX EX TENEBRIS. *c.* 1815–20. Drawing, sepia and ink washes, approx. 8¹/₈ × 5³/₄″. *The Prado Museum, Madrid*

BELOW LEFT: 49. TRUTH BESET BY EVIL SPIRITS. *c.* 1819. Drawing, sepia wash, 8¹/₁₆ × 5⁵/₈″. *The Metropolitan Museum of Art, New York*

BELOW: 50. WHAT A TAILOR CAN DO. *c.* 1793. Drawing, wash (for *Caprices*, No. 52), 7⁵/₈ × 4⁷/₈″. *The Prado Museum, Madrid*

51. GRAN DISPARATE. 1824–27. Drawing, black chalk,
$7^1/_2 \times 5^1/_2$". *The Prado Museum, Madrid*

52. PEASANT GIRL AND DOG. 1824–27. Drawing, black chalk,
$7^1/_2 \times 5^1/_2$". *The Prado Museum, Madrid*

53. AND SO THEY KIDNAPPED HER! *Caprices,* No. 8. 1793–96. $7^1/_4 \times 5^7/_{16}''$

54. TOOTH HUNTING. *Caprices*, No. 12.
1793–96. $7^1/_{16} \times 4^{11}/_{16}''$

55. IT'S HOT. *Caprices*, No. 13. 1793–96. $7^5/_{16} \times 4^3/_4''$

56. THEY MUST FIT TIGHTLY. *Caprices*, No. 17. 1793–96. $7^1/_4 \times 5''$

57. THE PITCHER BROKE. *Caprices*, No. 25. 1793–96. 7$\frac{1}{16}$ × 5$\frac{1}{4}$″

58. THEY ALREADY HAVE SEATS. *Caprices*, No. 26. 1793–96. 7⁹/₁₆ × 5⁷/₁₆″

60. THE DREAM OF REASON PRODUCES MONSTERS. *Caprices*, No. 43.
1793–96. $7^3/_{16} \times 4^3/_4''$

59. WHAT WILL HE DIE OF? *Caprices*, No. 40.
1793–96. $7^5/_{16} \times 5^3/_8''$

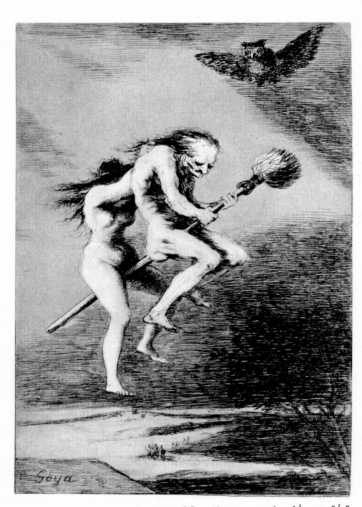

62. PRETTY TEACHER. *Caprices*, No. 68. 1793–96. $7^1/_{16} \times 4^3/_4''$

61. AND STILL THEY WILL NOT GO. *Caprices*, No. 59.
1793–96. $7^5/_8 \times 5^1/_4''$

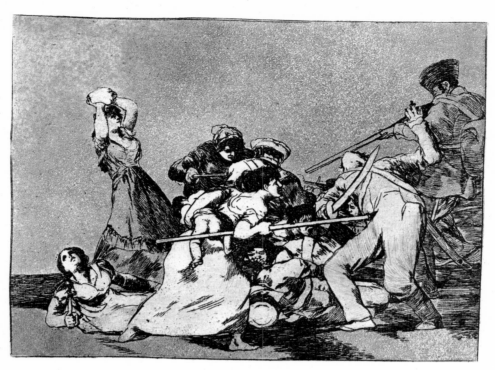

63. AND THEY ARE LIKE WILD BEASTS. *Disasters of War*, No. 5.
Begun 1808 (?) $5^3/_{16} \times 7^1/_{16}''$

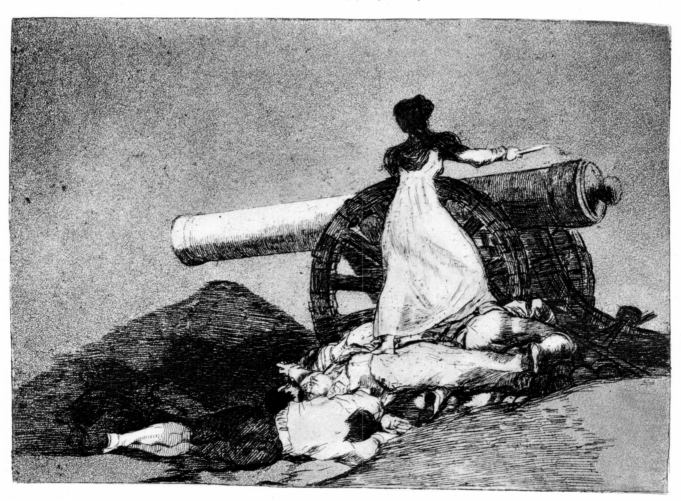

64. WHAT COURAGE! *Disasters of War*, No. 7. Begun 1808 (?) $5^5/_{16} \times 7^5/_{16}''$

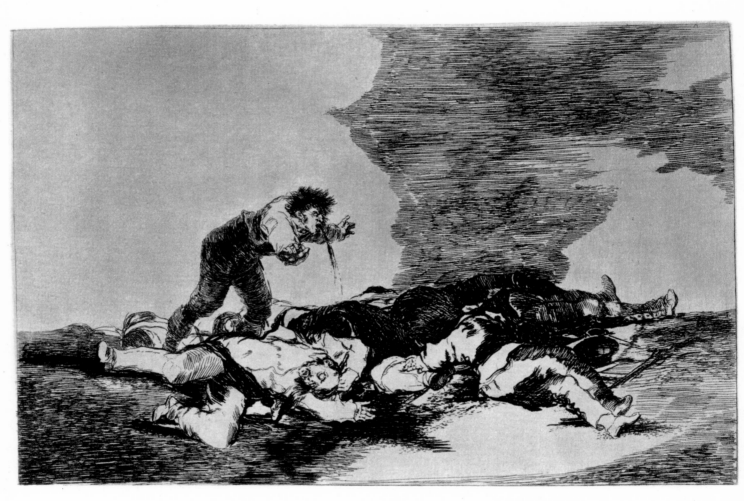

65. WAS IT FOR THIS THAT YOU WERE BORN? *Disasters of War*, No.12. Begun 1808 (?) 5 × 7¹/₂″

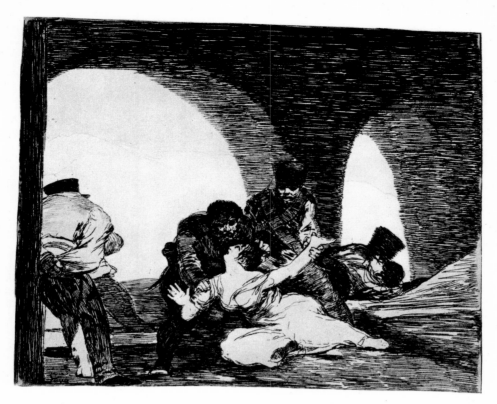

66. BITTER PRESENCE. *Disasters of War*, No. 13. Begun 1808 (?) $5^1/_8 \times 6^1/_4''$

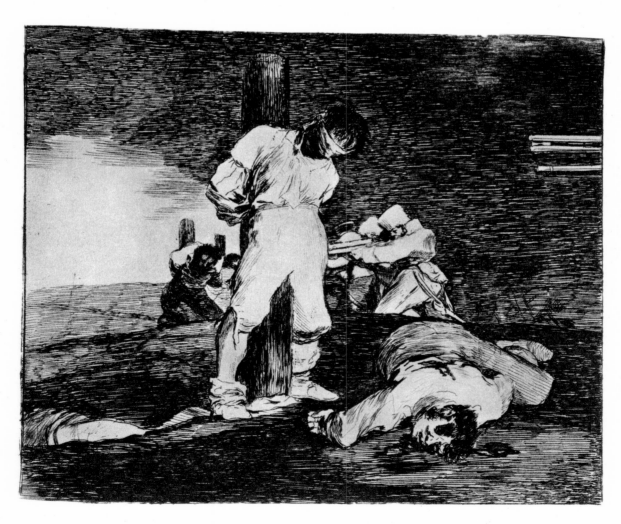

67. AND THERE IS NO REMEDY. *Disasters of War*, No. 15. Begun 1808 (?) $5^1/_8 \times 6^1/_8''$

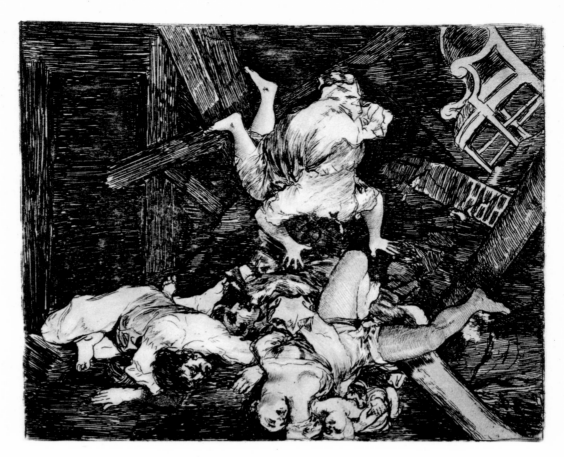

68. RAVAGES OF WAR. *Disasters of War*, No. 30. Begun 1808 (?) 5 × 6¹/₈″

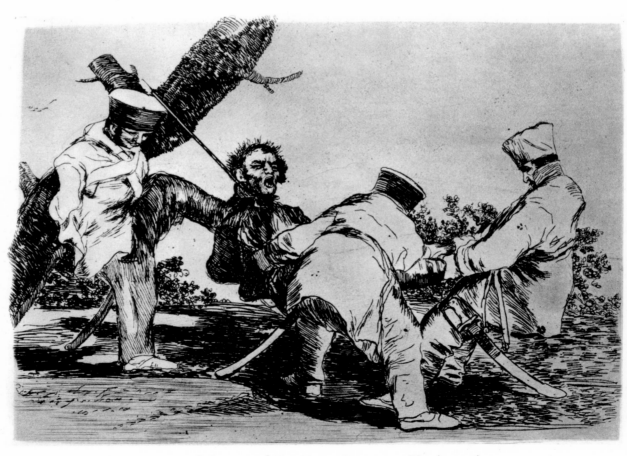

69. WHY? *Disasters of War*, No. 32. Begun 1808 (?) 5⁷/₁₆ × 7⁷/₁₆″

70. THE CARNIVOROUS VULTURE. *Disasters of War*, No. 76. Begun 1808 (?) 6³/₁₆ × 7¹³/₁₆″

71. ANOTHER WAY OF BAITING THE BULL ON FOOT. *Tauromaquia*, No. 2. Completed 1815. 7⁷/₈ × 12¹/₈″

72. THE AGILITY AND DARING OF JUANITO APINANI IN THE BULL RING AT MADRID.
Tauromaquia, No. 20. Completed 1815. $7^{15}/_{16} \times 12^{1}/_{8}''$

73. AN ACCIDENT THAT OCCURRED IN THE RING-SIDE SEATS AT MADRID, AND THE DEATH OF THE MAYOR OF TORREJON.
Tauromaquia, No. 21. Completed 1815. $8 \times 12^{1}/_{2}''$

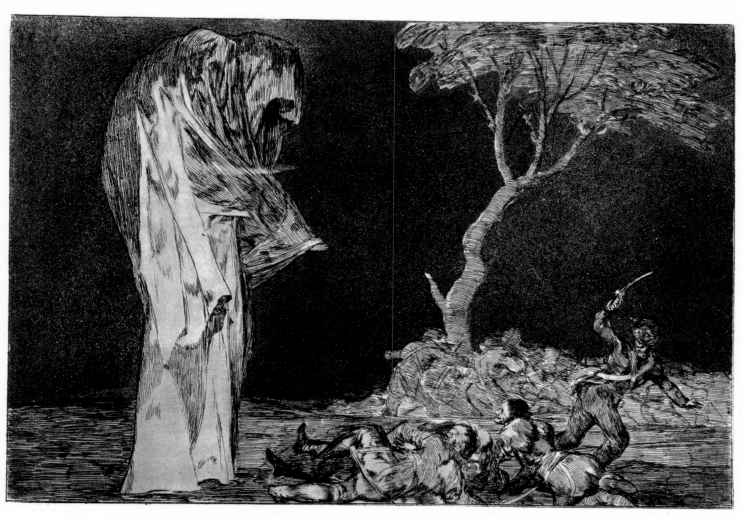

74. FOLLY OF FEAR. *Proverbs*, No. 2. *c.* 1819. $8^{11}/_{16} \times 12^{1}/_{16}''$

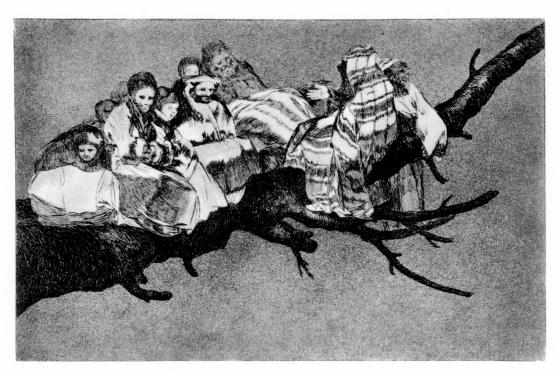

75. STRANGE FOLLY. *Proverbs*, No. 3. c. 1819. $8^3/8 \times 12^{11}/16''$

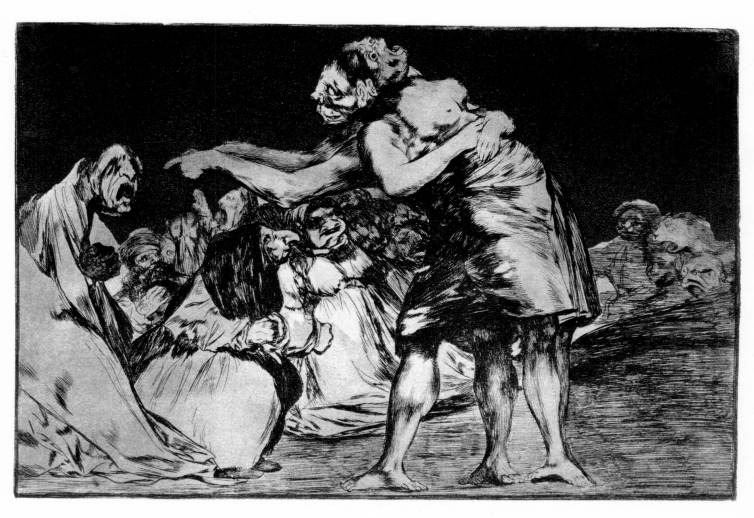

76. MATRIMONIAL FOLLY. *Proverbs*, No. 7. c. 1819. $8^9/16 \times 12^5/8''$

70

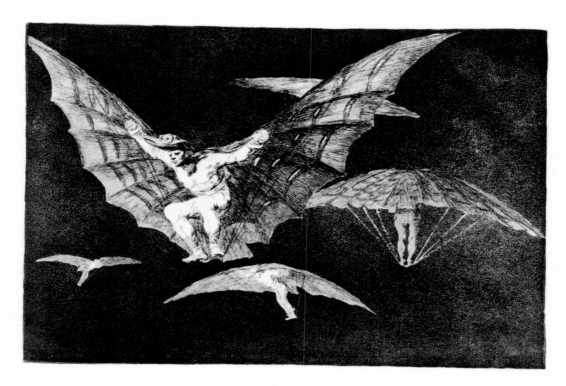

77. A WAY TO FLY. *Proverbs*, No. 13. *c.* 1819. $8^1/_2 \times 12^{13}/_{16}''$

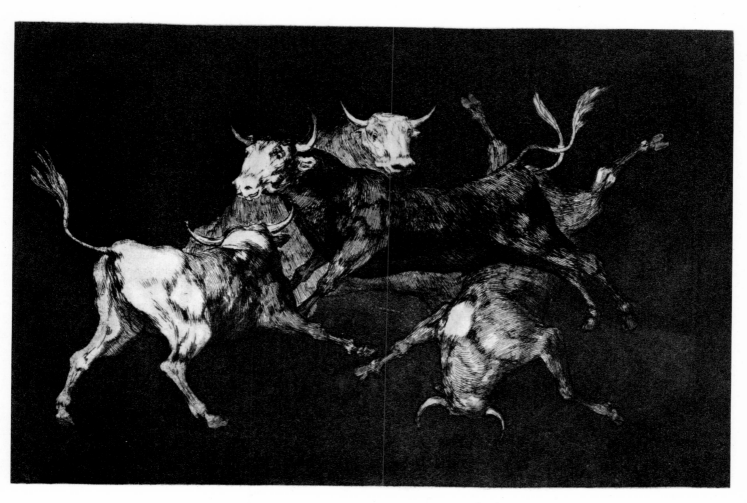

78. FOLLY OF BULLS. *Proverbs*, No. 22. *c.* 1819. $8 \times 12^5/_8''$

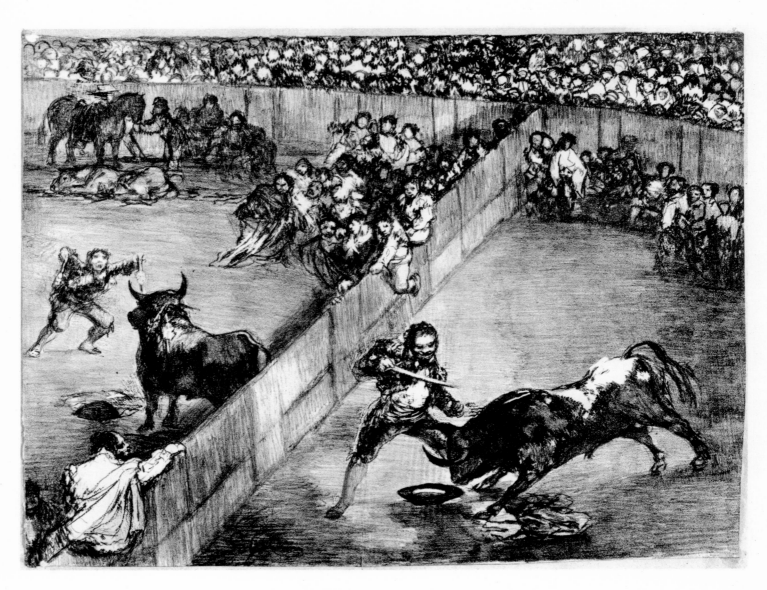

79. THE DIVIDED ARENA. Lithograph. $11^3/_4 \times 16^1/_8$"

COLORPLATES

Painted 1774

THE VISITATION

Wall painting in oil

Church of the Carthusian Monastery of Aula Dei, Saragossa

Eleven compositions once decorated the nave, transept, and chancel walls of this monastery church, not far from Saragossa. Only seven remain: *The Annunciation to Saint Joachim and Saint Anne*, *The Birth of the Virgin*, *The Marriage of the Virgin*, *The Visitation*, *The Adoration of the Magi*, *The Circumcision*, and *The Presentation in the Temple*. Early in the present century, the Buffet brothers—French painters whose manner was related to that of Puvis de Chavannes—completely repainted four of the paintings in the nave and, by the same process, destroyed the original appearance of certain other figures.

Monumentality and rhythms that are animated, though serene, dominate the stylistic features of these paintings. All are executed in oil on a dark-red ground. In the majority, Goya sought to counteract the excessively horizontal format by alternating groups of figures with open spaces, while shunning both confusion and strict symmetry. He also avoided frieze-like simplicity and the clash between the two dimensions by employing foreshortenings, convincing movement, light, and atmospheric values. Also, to create the sensation of an enveloping space, Goya frequently placed his figures so that they appear to stand behind the painting's lower border, and thus to be seen from below. In technique, there is an extreme economy of means. The forms are defined with prodigious facility, but without insistence. There is considerable simplification of details, and the texture of materials is suggested rather than imitated. The quality of light is manifest, as well as the manner of its falling.

All of these features are perhaps most vividly seen in *The Visitation*. There is both naturalistic narrative and human content; in this respect, Goya's work is related to Murillo's, both artists intimately fusing noble with popular elements. The scenes are composed as if seen from below their lower limits. They are not separated by vertical divisions, but possess, instead, a horizontal rhythm. Goya complements the severely neoclassic central figures with more narrative groups. He has successfully employed light from opposite directions, formed with summary tints. Not since Velázquez had a similar intensity been achieved with such restriction of expressive means. Goya's brush describes form, while simultaneously suggesting corporeal volume.